M000275460

·VICTORIAN·
CAPE MAY

To Bill and Susan Wallace

May my book add to your
enjoyment of the myriad
pleasures of Cape May.

June 2015

·VICTORIAN·
CAPE MAY

Robert E. Heinly

THE
History
PRESS

Published by The History Press
Charleston, SC 29403
www.historypress.net

Copyright © 2015 by Robert Heinly
All rights reserved

Front cover, top: Courtesy of Bill Trenwith. *Bottom*: Courtesy of Library of Congress.

First published 2015

Manufactured in the United States

ISBN 978.1.62619.895.1

Library of Congress Control Number: 2014959985

Notice: The information in this book is true and complete to the best of our knowledge. It is offered without guarantee on the part of the author or The History Press. The author and The History Press disclaim all liability in connection with the use of this book.

All rights reserved. No part of this book may be reproduced or transmitted in any form whatsoever without prior written permission from the publisher except in the case of brief quotations embodied in critical articles and reviews.

Over the years, many of my readers have urged me to compile my writings on the Victorian era into a book. This is that book, created as my thanks for your readership, encouragement and support.

Contents

Acknowledgements

I am indebted to the works of many contemporary historians and writers about Cape May and the Victorian era. Among them, I especially want to thank Jim Campbell, Bob Elwell, Jennifer Kopp, Ben Miller and Emil Salvini and Jack Wright, whose work especially inspired and contributed to mine.

I am also grateful to the *Cape May Star and Wave* and especially former editor Susan Krysiak. She first saw merit in my writings, and the newspaper continues to publish them.

Whitney Tarella Landis and Hilary Parrish of The History Press have been of great help in crafting my writings into this book.

Special thanks to the Mid-Atlantic Center for the Arts and Humanities, the keystone of Cape May's ongoing historic preservation and Victorian renaissance, for use of its multiple resources.

My biggest thanks go to my wife, Monica, my ever patient and encouraging proofreader and typist, for coping with this technological dinosaur and Luddite.

An Insider's Insights into Victorian Cape May

As a lifelong visitor to Cape May and now a permanent resident of the area who is intimately involved in helping visitors and locals alike learn more about the rich history and heritage of Victorian Cape May, as well as a career historian and educator, I'm pleased to offer readers unique insights into that history and heritage.

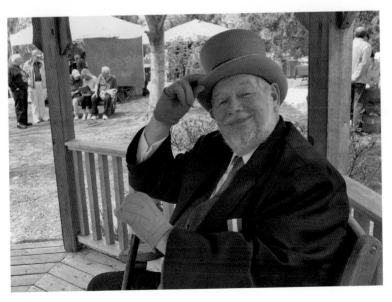

Dr. Robert E. Heinly as Dr. Emlen Physick. *Courtesy of Mid-Atlantic Center.*

INTRODUCTION

This book is not only about the rise of Cape May to the Victorian Queen of the Seaside Resorts in the 1800s but also about its decline for much of the 1900s and finally, and happily, its rebirth as a leading tourist and vacationing destination from the 1970s to the present based primarily on a renaissance of its Victorian buildings and culture.

In addition, it offers an insightful guide to both the outside and inside of those more than six hundred structures that were both the key to that renaissance and the reason Cape May is one of the few National Historic Landmark cities in the country.

I hope this book helps my readers develop the same understanding, appreciation and fascination for Cape May that I enjoy.

Meet the Victorians and Their Queen of the Seaside Resorts

Perspectives at the Turn of the Century

Whenever we enter a new century, as we did several years ago, we tend to look back with amazement and satisfaction at the old one and forward to the new one with hope and apprehension. The Victorians did so as the twentieth century dawned. This section is written from that perspective. The reader will note many parallels to what moderns experienced in 2000.

The last century was one of unparalleled change—change in how we lived, where we lived and how we made a living. Modern marvels of transportation and communication have shrunk our world. We are now not citizens of a state or region or nation but of the globe. Our modern cities with their huge populations and structures would be held in awe by our ancestors, as they offer comforts and opportunities but also problems and perils our predecessors never dreamed of. New inventions and wondrous technology, the marvels of modern science, have changed our economy's basis and, with it, the type of jobs men work at. No, not just men but all of us, because women are working outside the home in unprecedented numbers as physical jobs are replaced with mental and service ones. This same economic change has also brought new prosperity and leisure to all. While the excesses of the super-rich and the plight of the poor continue to be disturbing, most Americans lead lives of physical comfort, material wealth and leisure only fantasized about by their ancestors.

At times one wonders if the new ease of life is a two-edged sword, for Americans seem to lack our traditional physical vitality and fitness. New laborsaving devices have resulted in a less strenuous life at home and at work. Even in our leisure, many of us tend to be less physical. The rise of professional sports seems to be turning us into watchers not doers. The disease of spectatoritis is upon us. Hopefully, the recent emphasis on healthy exercise and activities, such as biking and hiking, will remedy this. Alarmingly, there has been a parallel decline in traditional mores and values. Led by artists and entertainers, advocated by our colleges and promoted by the media, old and new, the traditional civilities are openly flaunted. Beyond a decline in civility, there has been an alarming increase in violence in our society along with an increase in blatant sexuality. Our language has become increasingly vulgar. Many seem to respect nothing and no one. The family itself, long the basic building block of our society, seems in decline. This has had an especially negative effect on our young people. Our political leaders share in the blame for this both in the laws they pass or modify and in the example many set in both their personal and public lives. The scandals of the latter are made perhaps too public by a too probing and sensationalistic press. One wonders about the recent war and the press's influences on it. Did the media unduly influence national opinion concerning the war?

Not that all matters political and governmental have declined. We have had great leaders as well this century and made great strides for democracy both internationally and within the country. Foreign dictatorship and oppression have been overcome and rights extended to more and more Americans, although there is still much work to do. Sadly, too many have been martyred in these efforts, including even presidents. The wars of this century, both popular and unpopular, have been too many and too brutal. They've been fought with ferocity and with weaponry so terrible that one worries about the end of civilization as we know it should another occur employing even more modern technology.

In retrospect, change—unprecedented change, ever accelerating change, change affecting every aspect of our lives—was the theme of the last century. Overall, we have met the challenges of change. Our success in the new twentieth century depends upon continuing to do so.

Yes, the new twentieth century, not the twenty-first! The views above were those of many of our Victorian ancestors in 1900. It was easy to mistake them for those of a contemporary observer in 2000, wasn't it? The Victorians, so distant...so different...or were they? Was their world as different from ours as one might initially believe? Perhaps not! Our Victorian analyst identifies

ever-accelerating, all-impacting change as both the keynote of the past century and the challenge for the next. How like today!

Victorian life was transformed by inventions and technology as much as ours has been. The Victorian world was shrunk by steamboats, railroads and streetcars and by the telegraph and telephone just as ours has become even more compacted by automobiles, airplanes and rockets and by radio, television and the Internet. The impact on them of steam and electric power and of standardized time, sized clothing, advertising, elevators, department stores and skyscrapers was just as great as the impact of nuclear and solar energy and movies, microwaves, malls and computers upon us. Their urban problems and promise are still with us, now expanding into the suburbs. The Victorians saw their economy change from producing agricultural products to industrial ones as ours has, in turn, changed to one of providing services. Labor-management and environmental problems plagued both centuries. Women are still defining their roles in the workplace as they enter it in still growing numbers. Leisure time and overall affluence have continued to grow, and so have concerns about our resultant health and physical fitness. We, like the Victorians, still worry about moral and civil decay as well, including the dynamics of the family.

In the arena of international affairs, our Victorian ancestors could look back on the War of 1812, Mexican War, Civil War and Spanish-American War, just as we've experienced two world wars, Korea, Vietnam and the Persian Gulf. The War of 1812 was as unpopular with as many Americans in their time as the Vietnam War was in our time. The media played as big a role in getting us into the Spanish-American War as it did in getting us out of Vietnam. The similarities in politics and government are also striking. For every Hoover, Nixon, Harding and Clinton, the Victorians had a Grant, Andrew Johnson, Buchanan and Cleveland. They lost Lincoln and Garfield as the twentieth century lost McKinley and Kennedy. Equal participation in our government and society by all regardless of race, color, sex or economic status still remains a goal, not an accomplishment.

As we today look back upon the twentieth century, we do so with the same amazement and satisfaction that our Victorian ancestors viewed the nineteenth century. Similarly, we look forward to the twenty-first century with the same mixture of hope and apprehension with which they anticipated the twentieth century. Our worlds, and the people who shaped and were shaped by them, are not so different after all. The Victorians are closer ancestors than we realize!

Introduction to the Victorians and Their World

The Victorian period coincided with the reign of Britain's Queen Victoria from 1837 to 1901. It actually went beyond her reign to the start of World War I in 1914. Since the British Empire was the western (and probably whole) world's most powerful nation economically and politically, it was also the trendsetter culturally. Therefore, in the western world, particularly in the United States and the British Empire, the upper classes especially adopted the ways of the British monarch, including referring to themselves as Victorians. In the United States, the Victorian period included the Civil

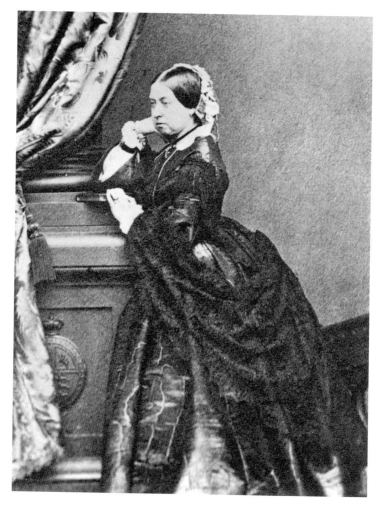

Queen Victoria. *Courtesy of the Library of Congress.*

War, the Mexican War, the Spanish-American War and the Ages of Western Expansion, Imperialism and Industrialization. Among the presidencies it included were those of Lincoln, McKinley, Theodore Roosevelt and Wilson. It ended with the United States replacing Great Britain as the world's greatest power, although it would take World War II to confirm this. Never before had Americans felt so powerful; never before had so many material goods been available and had so many had the wealth to obtain them. While the gap between rich and poor widened, a new middle class emerged as the purchasing power and lifestyles of most Americans improved as never before in our history.

As a result of the above, Victorian Americans, especially the upper class and newly created middle class (who "resorted" in Cape May), were as a whole extremely optimistic, self-confident, patriotic and materialistic. They were also more religious, class conscious, formal and private than most contemporary Americans. They passionately pursued the "rags to riches" dream personified in the Horatio Alger novels popular during the period. Those who had wealth were equally passionate in their pursuit of maintaining it. Above all, Victorian Americans were obsessed with what they called "earnest striving" to improve both their world and their socioeconomic class and with the material symbols and respectability of the upper-class lifestyle. Thus, their houses had wraparound porches and parasols designed to maintain the pale "alabaster beauty" skin of the leisure class in contrast to the working class's suntans. Thus, their houses had sideboards and service a la Russe in their dining rooms to display their numerous servants and extensive collections of stemware, silver and china. Thus, their houses had entrance halls where servants screened visitors and guarded the privacy, sanctity and status of the family.

Given their beliefs, some Victorian behavior that we find unusual today becomes logical. Their homes, cluttered and ostentatious to us, were both the display cases of their affluence and refuges of gentility from a highly competitive business world—a world that was largely free of government regulation and in which only the strong survived (and deserved to do so, according to the prevailing philosophies of laissez-faire and social Darwinism). While men struggled in this outside world, women were idealized and worshipped as the preservers of decorum, culture and, above all, the family. Women were the civilizers of society. Victorians viewed affluence and leisure as rewards, not just for their earnest striving, but their virtue as well, gifts from an approving God for their contributions to the evolutionary improvement of mankind.

VICTORIAN CAPE MAY

The Victorians were a people of contrast and contradictions, as was their era. These were a people and this was a period of paradox. This was perhaps understandable since they lived in a time of constant change and transition from the old to the modern. Thus, the Victorians could appear hypocritical by today's standards. They could be optimistic yet full of anxieties, idealistic yet class and social conscious, ruthless in business yet extremely religious. The personification of the period, the so-called robber barons of finance and industry, invested many of their millions in the arts and charity yet ruthlessly manipulated monopolies and governments. They felt a paternalistic relationship with their workers yet sought to crush the workers' efforts to organize, to help themselves. They were extremely ethnocentric, believing that their civilization was not only the best but made so by God. At the same time, they were extremely evangelical, believing they had a moral obligation to bring the benefits of the fundamentals of their civilization (democracy, capitalism and Christianity) to the "primitive" cultures elsewhere around the world. Victorians had restored the union (Civil War), won two foreign wars (Mexican and Spanish-American), settled the West and begun to bring the "blessings" of Christianity, democracy and free enterprise capitalism to the world. They had wealth, material goods and creature comforts their ancestors had only dreamed about. The Victorians experienced the introduction of the trolley and telephone, electric light and elevator, the skyscraper, the indoor toilet and the automobile in their lifetimes. They now enjoyed canned and refrigerated foods, Coca-Cola, sized clothing, home mail service and shopping, as well as shopping in department stores. They saw time standardized, sports professionalized and Christmas first popularized and then commercialized. Their railroads and steamships spanned and shrank the world. True, the pace of change was unprecedented and sometimes bewildering, but they had faith that it was all for the betterment of themselves and mankind. The Victorians' accomplishments, philosophies and view of their world unfortunately also allowed them to consider what we view as racial and sexual inequality, government corruption, business monopolies and the poverty of the lower class as the natural order of life. However, a growing number of reformers were focusing attention on these problems.

It was a period and world with many names—the Gilded Age, the Age of Excess, the Industrial Age, the Age of Conspicuous Consumption—but it remains best known as the Victorian period. Welcome to the fascinatingly complex world of the Victorians!

MEET THE VICTORIANS AND THEIR QUEEN OF THE SEASIDE RESORTS

A People of Paradox

Understanding the beliefs and values of the Victorians and the lifestyle they produced can be initially baffling. So much of what the Victorians believed and did seems contradictory and confusing. Indeed, they were a people of paradox, but in being so, they were simply reflecting their times, which were equally contradictory and complex.

The Victorian era was one of dynamic change. At its core, the era was a transition from an agricultural, agrarian culture to an industrialized, urbanized one. Almost daily, traditional varieties and values were being challenged and then transformed to reflect changes in all aspects of life, including how people made a living, where they lived, how they traveled and communicated and, indeed, the basic scientific assumptions about the nature of humankind and the universe.

The change in the way time was viewed offers an instinctive example. When the era started, the important factors in telling time were the sun, the moon and the seasons. Life was organized around the amount of available sunlight and the climate. By the end of the era, electricity illuminated the night and warmed or cooled the days. Precision of time and punctuality were demanded in factories and businesses. Led by the new railroads that spanned the continent and the steamships that spanned the globe, time was standardized into set zones (1883). Work was now done in regular timed shifts rather than at the whim of the weather and the availability of sunlight. Work itself, more and more, was not done at home and with family and friends as before but at an office or factory among relative strangers who were often rivals for the rewards of productivity. Many of the occupations at which the Victorians worked were not in existence at the start of the era. Autoworkers were replacing blacksmiths, and telephone operators were replacing town criers. Who had dreamed of being a psychologist, or an elevator operator, or a professional athlete in 1840?

Not only was the very fabric of everyday life changing, it was changing at an ever-increasing pace. The Victorians had to cope with what we moderns call "future shock," but they not only did not have a name for it, they did not even realize it existed. Nevertheless, they felt its impact on their lives, minds and emotions daily. In coping with ever-accelerating and ever more extensive change, the Victorians understandably tried to keep a foot in both worlds: past and future. Thus, their often paradoxical and contradictory beliefs and behaviors. Outwardly self-confident almost to the point of arrogance, many were inwardly insecure. Many prided themselves on

their rugged individualism yet worked in teams in offices and factories and joined social and cultural clubs in unprecedented numbers. They idealized women, virtually worshiping them as mothers and the essences of all that was good and civilized about society. Yet many denied women basic political and economic rights and opportunities, creating a totally male-dominated world. They stressed the virtue of improving one's socioeconomic class as the American dream yet created increasingly complex social and behavioral barriers between these classes. Many Victorians were extremely religious yet extremely intolerant of religious, racial and cultural differences. Most Victorians took great pride in their respectability, virtue and sophistication and constantly emphasized these traits, yet many of their actions in their largely unregulated business world would have made the barbarians of history blush. These, then, were the Victorians, living in a period of unprecedented change and simultaneously shaping and being shaped by these changes. Fascinatingly complex, they were truly a people of paradox.

The Importance of Historical Perspective

Twin sirens lurk in the sea of history, luring those seeking to understand and appreciate the past onto the reefs of misunderstanding and misinterpretation. These twin dangers are temporocentrism and ethnocentrism. Temporocentrism is the belief that your times are the best of all possible times. All other times are thus inferior. Ethnocentrism is the belief that your culture is the best of all possible cultures. All other cultures are thus inferior. Temporocentrism and ethnocentrism unite to cause individuals and cultures to judge all other individuals and cultures by the "superior" standards of their current culture. This leads to a total lack of perspective when dealing with past and/or foreign cultures and a resultant misunderstanding and misappreciation of them. Lorelei-like, temporocentrism and ethnocentrism tempt moderns into unjustified criticisms of the peoples of the past. Making ex post facto laws is unconstitutional. Making ex post facto judgments of the past is unfair.

The Victorians were prime advocates of temporocentrism and ethnocentrism. Ironically, they are now also prime victims of both. A sense of historic perspective is vital to a true understanding and appreciation of the Victorians. The Victorians should be viewed in the context of their own times and culture, not ours.

Some twenty-first-century Americans flinch in disbelief and cringe in disgust when considering such Victorian beliefs as social Darwinism, Manifest Destiny, mission and muscular Christianity. The elitism of the Victorians' emphasis on respectability and substance, their equating of wealth with God's favor and therefore virtue, the ostentation of their "more is better" interior and exterior décor and the formalism of their fetish with decorum and etiquette first perplexes and then alienates moderns. How could they do that, how could they believe that, we ask retrospectively? We then shake our heads in condescending condemnation. In doing so, we reveal our temporocentrism and ethnocentrism and lack of historical perspective.

History is a dynamic process: sometimes evolutionary, sometimes revolutionary. Today's reactionary was yesterday's progressive. What may seem conservative to us today may actually have been quite liberal in the context of its times. When the Victorians sought to evangelize the globe for democracy, capitalism and Christianity, they felt they were involved in an effort that was to varying extents idealistic. Their impulse to become involved in Manifest Destiny, mission and muscular Christianity was seen by them as much more enlightened than the totally exploitive imperialism of the past. Many upper-class Victorians honestly believed they had a moral obligation to be good role models, to set high standards of dress, manners and lifestyle for those less fortunate to aspire toward via earnest striving. To a significant degree, their actions were enlightened when compared to the standards of the 1700s, not the 2000s.

Each culture and each age is most validly viewed and evaluated in its own historical context. Guided by historical perspective, moderns can avoid the reefs of misconception that endanger their ability to understand and appreciate the Victorians.

How Cape May Became Queen of the Seaside Resorts

By the beginning of the Victorian era (1837–1914), an interface of influences had come together to form a virtual positive perfect storm of tourism that caused Cape May to become the "Queen of the Victorian Seaside Resorts." This confluence of motivation, transportation and location made the town at the tip of the Jersey Cape the most desirable vacation destination for an ever-expanding segment of the American population, mainly the newly

emerging middle class. As the era evolved, more and more members of the lower class added to this influx. It became Victorian Americans' most popular seaside resort.

The Victorians' motivations for vacations (they called it resorting, thus the places they went to were resorts) were new and many. The primary ones were that they had increased leisure time and disposable income thanks to the prosperity caused by the Industrial Revolution. Indeed the middle socioeconomic class was created by the Industrial Revolution, formed by the new white-collar workers of the age such as middle managers of industry, finance and commerce and scientific, medical and legal professionals.

Victorians had a philosophical dilemma about how to use this leisure time. According to their basic belief in the Protestant work ethic, idle hands were the potential tools of the devil. God had rewarded their hard work with wealth and leisure time. How could they please Him in using them? The solution was to engage in activities to make themselves even better people piously, intellectually and physically (improving their health). They would recreate themselves. The ways used to do this became known as recreational activities, activities to improve one's spirit, mind and body.

A growing number of Victorians lived in the urban areas that had formed around industries. Victorian science was revealing how unhealthy cities were becoming. Thus, to recreate one's health, one had to resort to traveling to a healthier locale. These spots thus became known as resorts and the act of going to them known as resorting, as mentioned earlier. At these resorts, Victorians simultaneously improved their health while attending educational and religious seminars and meetings. Surely God was pleased! Many of these gatherings were known as Chautauquas, named after an early one located on Lake Chautauqua in New York.

Why resort to Cape May? There were two main reasons: ocean bathing and its location. Ocean bathing combined with a breathing in of the invigorating sea breezes was known to be good for your health and enjoyable besides. King George III of England had first popularized ocean bathing in the late 1700s. Prior to that, the only sane persons found swimming in the ocean where those whose ships had sunk and were thus frantically trying to save their lives. However, as soon as the king of the most powerful nation in the world advocated ocean bathing, the practice was adopted by trendsetters on both sides of the Atlantic.

The location of Cape May was ideal for resorters seeking to recreate themselves via ocean bathing. Besides its obvious seaside location, it had wide, gradually sloping beaches and a moderate climate. It was

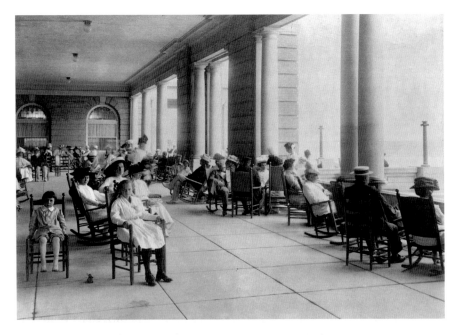

Piazza, Hotel Cape May, circa 1909. *Courtesy of the Library of Congress.*

located farther south than most people realized (about the latitude of Washington, D.C.) and surrounded by ocean and bay waters that both moderated the climate and stimulated constant breezes. It was noticeably cooler in the summer (and warmer in the winter) than the major cities nearby. In addition to improving one's health, one could improve their piety and intellect in the Chautauquas and camp meetings at Cape May. Cape May's location amidst the major East Coast cities from Savannah north to Boston (we call it the East Coast megalopolis today) made it "the northernmost southern resort and the southernmost northern resort." Its peninsular position also provided relatively easy transportation access during the 1800s, which was mainly a time when people traveled by water if possible, first by sailing ship and then increasingly by the newly invented steamboat.

The steamboat was one of two major transportation improvements that stimulated Cape May's rise as a resort. The second, starting at mid-century and becoming increasingly popular, was the railroad. The flat terrain of southern New Jersey was ideal for railroading. As travel by steamship and railroad became faster and more affordable, it took less and less time and money to travel to Cape May, opening access to resorting there to more and

more people. Even the less affluent could eventually take a day trip via train to enjoy Cape May.

Another motivation for resorting to Cape May was as a status symbol. To be able to do so was evidence of one's rising affluence and resultant socioeconomic status. Those who had "made it" or wanted others to think that they had wanted to be seen resorting in Cape May to recreate themselves.

Local residents of Cape May also benefited from its being a popular resort. Tourism presented increased economic and employment opportunities for them beyond traditional options like fishing, farming and being river and bay pilots. Seasonal supplements were found by farmers and fishermen selling food to hotels and summer residents or by working in motels and other service industries. Merchants had more customers.

Thus, Cape May was the beneficiary of the confluence of social, economic and geographic influences, involving motivation, transportation and location in becoming the Queen of the Victorian Seaside Resorts during the 1800s.

A Recent Resorting Renaissance

Cape May's location wasn't changed, but the motivations and transportation influences have. Similarly, there are changed social and economic factors in the creation of this second golden age.

During much of the twentieth century, Cape May lost a lot of its tourism. Its peninsular location, so desirable in an era of water transportation, became a handicap when people's transportation preferences changed to overland methods, mainly the railroads and then the automobile. It now took too long to get all the way down to Cape May. Places like Atlantic City were much more conveniently located.

By the latter half of the twentieth century, the summer vacation had become a tradition. Most Americans of all socioeconomic classes had the time and money to enjoy one, ranging from a weekend to a full summer. For many people in the mid-Atlantic region, this meant a trip to the Jersey shore. Philadelphians especially migrated "down the shore" each summer. Yet Cape May seemed to be a sleepy little town that time and transportation preferences had forgotten.

Early in the 1970s, Cape May decided to use its past to improve its present and future. Using some federal and state funding and a lot of vision, entrepreneurial spirit and private enterprise, the town restored many of its

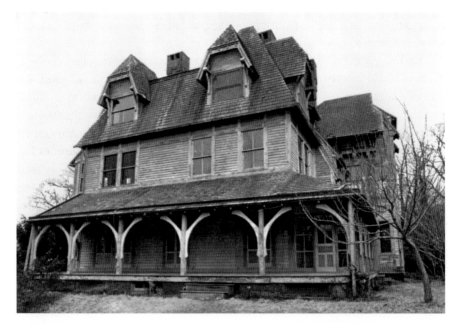

The Physick Estate prior to renovations in the 1970s. *Courtesy of Mid-Atlantic Center.*

neglected Victorian buildings. The Mid-Atlantic Center for the Arts and owners of bed-and-breakfast inns were leaders in this effort. It also became the site of a variety of cultural tourism activities based on its Victorian heritage such as fairs, festivals, concerts, the theater and walking, trolley, boat and horse tours. Tourists began returning to Cape May because it offered a unique blend of modern seashore resort amenities and attractions like outstanding restaurants, shopping and marinas and modern hotels and motels combined with Victorian ambiance and events. Restored Victorian bed-and-breakfasts and Victorian hotels prospered along with these more modern facilities. In 1976, Cape May was designated one of the few National Historic Landmark cities in the nation. Happily for Cape May, interest in the Victorian era became very popular at the same time this was happening. An added bonus was that many historic and cultural events occurred during the off-season, the so-called shoulder seasons of spring and fall, thus greatly extending the tourist season in Cape May with events such as Victorian Week, Spring Festival, Sherlock Holmes Weekends, the Cape May Music Festival, the Cape May Jazz Festival, the Cape May Film Festival and the Food and Wine Festival.

Some critical transportation developments decades earlier had made it easier for these tourists to get to Cape May in their automobiles. The Ocean

Drive through the various South Jersey seashore resorts had been completed in the 1940s. Even more convenient was the Garden State Parkway, which reached Cape May in 1956–57. This stimulated a large influx of New Yorkers. Also important was the establishment of the long dreamed of Cape May–Lewes Ferry in 1964, easing automobile access from Baltimore; Washington, D.C.; and points south.

Some key municipal improvements had taken place in Cape May prior to the Victorian renaissance. The seawall and promenade was erected in the 1960s and the Washington Street pedestrian shopping mall created in the early 1970s. A "temporary" Convention Hall had replaced one ruined by a storm in 1962.

During these same decades, retirees began moving into the Cape May area both along the bayshore north of the canal and in the long underdeveloped eastern part of the city. They provided an all-year-long social and economic stimulus to the area.

During the 1980s and 1990s, three new forces added to this positive perfect storm of revitalization for Cape May: fishing, birding and dining.

Fishing, both commercial and recreational, had been part of the area's economy and lifestyle since its founding. The expansion of the harbor early in the 1900s had resulted in a fishing boom well into the 1920s. This commercial and recreation fishing had boomed again after World War II. To this was added offshore sportfishing in the 1970s and 1980s. Today, Cape May is one of the leading commercial fishing ports on the East Coast and hosts the world's richest boat-for-boat sportfishing tournament. All this and pleasure boating too.

Since the early 1800s, the Jersey Cape has been famed for its excellent birding. Ornithological giants including Alexander Wilson and Witmer Stone visited it regularly. Birding was somewhat of a minor cult recreation until the 1980s, when it began to expand in popularity. Today, it's one of the leading recreational activities in the nation. Cape May today is arguably the birding capital of the nation, site of events such as the World Series of Birding.

As part of Cape May's modern resorting renaissance, it has become a Mecca for fine dining. Some of the best restaurants in the state are located here. An annual list of the top restaurants in New Jersey always includes several from Cape May. Beyond those, the town has become known for excellent restaurants for every budget, offering a wide variety of cuisine.

Thus, today we find Cape May in the midst of a second positive perfect storm of resorting. This second golden age features a mixture of Victoriana,

fishing, birding and dining, along with its ever-beautiful beaches. Add an ever-increasing number of retirees making the area their permanent home, and Cape May's resorting renaissance is complete.

Surely the spirits from its past of this "most haunted town in America" (another boost to tourism) are smiling at its present. Only they might know how long this second golden age will last.

The Four Cornerstones of Victorian Culture

Victorians believed that they were blessed by God to live in the best of cultures (ethnocentrism) in the best of times (temporocentrism). If asked what the cornerstones of their culture were, they would readily reply capitalism, Christianity and democracy, to which social scientists have added optimism.

In the Victorians' view, not only was theirs the best of cultures in the best of times but it was getting increasingly better as well. Given the scientific and material progress during their era, when time, space, disease and even nature seemed to be being increasingly controlled if not conquered by their science and resultant technology, who knew what wonders the future held? In every day, in every way, they felt things were getting and would get better and better.

Why were things getting better and better? Because of capitalism, Christianity and democracy.

Capitalism had allowed the Industrial Revolution to reach its full potential and had similarly stimulated scientific and technological advancement by rewarding excellence and achievement while simultaneously stifling mediocrity and sloth. The capitalism of the Victorians was completely laissez-faire, free enterprise capitalism, unrestricted by governmental regulations and a social conscience. It was a socioeconomic system based on the thoughts of Malthus, Darwin and Spencer, of survival of the fittest for the betterment of the human race.

By Christianity, the Victorians meant Protestant Christianity. The Christianity of Victorians was Presbyterianism, Episcopalianism, Congregationalism and Methodism. It was the Christianity of the Protestant work ethic with God rewarding hard work and virtue with wealth. It was a Christianity that equated wealth and success with virtue and God's favor and poverty with immorality. It was the perfect complement to their concept of capitalism. Only late in the era would the social gospel movement emerge to temper these views.

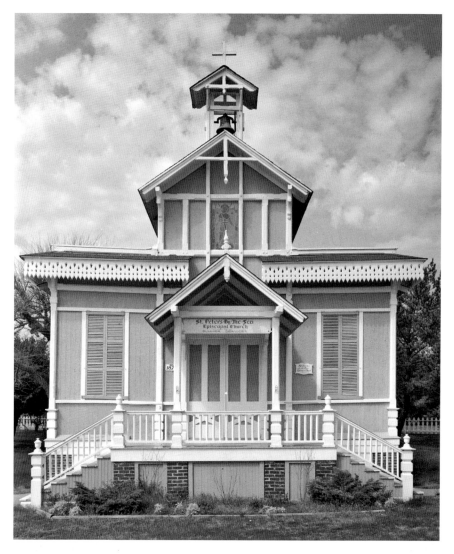

St. Peter's by the Sea Episcopal Church, Ocean Avenue at Lake Avenue, Cape May Point. *Courtesy of the Library of Congress.*

Victorian democracy was representative, republican, Hamiltonian democracy. It was control of the country by those who had proven themselves superior among humankind by their achievements in the business and academic worlds. Only those men, of proven ability and with a stake in the success of the nation, should guide the nation. They would elect their leaders from among their ranks. It was what the Victorians considered a

meritocracy. The one man, let alone one person, one vote concept was viewed by the Victorians as mobocracy, a sure path to societal chaos and collapse. Let those who want political power prove themselves worthy of it in the arena of social Darwinism, they felt.

These, then, were the cornerstones of Victorian culture: complete laissez-faire free enterprise capitalism, Protestant democracy, republican democracy and unbounded optimism. They were a gift from God to his chosen people living in the best of cultures in the best of times whose future seemed as limitless as it was bright.

Understanding the Victorians: Ethnocentric and Temporocentric

The society and lifestyle we call Victorian evolved from the complex interactions among the industrial, intellectual, cultural, scientific and technological revolutions occurring simultaneously during the nineteenth century. In the next few sections, we'll be examining the beliefs, or views, of the Victorians that evolved during that century and that formed the foundation for their era, society and lifestyle. An understanding of these Victorian views will help answer questions such as how they could believe what they believed and why they acted the way they did, which are commonly posed by those interacting with the Victorians and their era for the first time. The Victorians were rational people who came to logical conclusions in reaction to the conditions of their times. They are best understood in the context of these times and conditions.

As might be expected of times with multiple revolutions in the basic way of life and thought, Victorians lived in a world of constant change. Two of the most basic were where one lived and how one made a living. In 1800, Americans lived in a rural, agricultural world. By 1900, their descendants lived in an urban, industrial world. By conservative estimates, half of Americans by 1900 lived in or near cities and earned a living in factories or supplying raw materials to factories or by distributing or selling the products of factories.

Lifestyle-changing revolutions had occurred in transportation, communication and energy production as well. Power in 1800 was provided by human and animal muscle, wind and water flow. By 1900, the era of steam power was already transitioning into the age of gasoline and electricity.

The Mooring. *Courtesy of H. Gerald MacDonald.*

Transportation in 1800 was drawn by animals or driven by wind and water flow. By 1900, the horseless carriage was replacing the horse and carriage, and steamboats had replaced sailboats. The railroads were at their peak, and soon the airplane would arrive. Information traveled as fast as a horse could gallop or a boat could sail in 1800. By 1900, the telephone and telegraph were well established.

The impact of these technological changes on lifestyle was astounding. The Victorians' world had simultaneously shrunk in travel time and expanded in accessibility. Time had been seemingly mastered, if not conquered, by speed of movement. The night had been conquered by gas and electric

illumination. A seemingly never-ending flow of innovations and inventions improved one's material life: skyscraper and streetcar, elevator and electric lights, camera and sized clothing and hot dogs, hamburgers and home mail service, to name just a few. It had become the best of times; the best times of all times.

Given the above, is it any wonder the Victorians concluded they were living in the best of all possible cultures in the best of all times? Social scientists call the former belief ethnocentrism and the latter temporocentrism. In understanding the views of the Victorians, it is vital to place them in this ethnocentric and temporocentric context. It is the mortar that holds the foundation of the Victorian era, lifestyle and mindset together.

Basic Victorian Beliefs and Behaviors: Seeking Status

The basic Victorian beliefs behind the drive to excel and win the rewards of excellence were the Protestant work ethic and social Darwinism. Their belief in them meant that they felt their worth as human beings was determined by their wealth.

The Victorians inherited the Protestant work ethic from previous Calvinist and Puritan beliefs. In brief, it held that God rewarded hard work and diligence with success in the form of wealth. The Victorians believed the prosperous were of greater virtue than the poor, whose plight was due to sloth and immorality. Thus, the rich were in greater favor with God than the poor. The poor were poor because of insufficient earnest striving upward.

Social Darwinism was a mutation of Charles Darwin's theories on evolution, natural selection and survival of the fittest. The father of social Darwinism was English philosopher and scientist Herbert Spencer, who applied Darwin's ideas about lower animals to human beings and human societies. Spencer started with the basic premise developed in the eighteenth century by Thomas Malthus that since resources were limited and human population and needs expanding at an ever-increasing rate, all of life was a struggle for these resources. Spencer added that those who best adapted to changing socio-environmental conditions flourished, and those who couldn't or wouldn't adapt perished. The result was racial and societal improvement. In the Victorian view, wealth and power were the prime indicators of this

The Humphrey Hughes House. *Courtesy of H. Gerald MacDonald.*

evolutionary superiority. Thus, the wealthy and powerful were advancing human individual, racial and societal improvement, while the poor were retarding same. And how could they believe all this?

Moderns should remember that these beliefs were born in a context of unprecedented economic expansion and improvement in the material standard of living. The Industrial Revolution and its satellite commercial, scientific and technologic revolution had catapulted many people to sudden wealth and prosperity. The middle class had been created full of the newly rich. Many individuals had lived the rags-to-riches plot of the wildly popular

stories of Horatio Alger in their own lives. Thus, they felt that with enough determination, anyone could duplicate their success.

The Victorians' complementary beliefs in the Protestant work ethic and social Darwinism also appealed to two of the biggest forces in their lives: religion and science. They worshiped both. They were God's chosen people, and they thanked God daily for this. Their science and technology had made their lives immeasurably better, and for this they also virtually worshiped science. From esteemed chairs of academia in the finest schools of the land, they heard the correctness of social Darwinism espoused. From the pulpits of most churches on most Sundays, they heard the virtues of the Protestant work ethic evangelized. The leaders of business and government also reinforced these beliefs. It was also easy for the upper classes to believe because it was so very self-congratulatory. Clearly, they were people of the better sort, more virtuous, more in favor with God and more evolutionarily advanced, and thus superior not only economically and politically but also theologically and anthropologically. What a wonderful bonus added to their materially improved lifestyle. If only people of the lesser sort would earnestly strive upward with greater zeal, they, too, could enjoy the benefits of a Victorian society blessed by God to be the best of cultures in the best of times created and populated by the best of people.

Basic Victorian Beliefs and Behaviors: Showing Status

To provide historical and cultural anthropological perspective, we should remember that status seeking and status showing are classic behaviors of the newly rich in most societies in most times throughout history. Most of the Victorians, made newly rich or richer by the Industrial Revolution, were classic exemplars of this.

The Victorians showed their advanced socioeconomic and, thus (in their view), anthropological and moral status in virtually all aspects of their lifestyles. Victorians showed their status in the way they dressed and spoke; in their obsession with etiquette, manners and proper decorum; in showing that they were cultured connoisseurs of culture and of the arts and literature; and by displaying proper taste and refinement in all matters. Above all, they were obsessed with projecting an image of substance (wealth) and, therefore, respectability. All of these were ways

one could clearly mark oneself as being of the better, as contrasted to the lesser or meaner sort in the Victorians' view.

Clearly, then, the Victorians could and often did become victims of their own status seeking. They had to adopt each new trend or style in clothing, architecture, interior décor and the arts. Their homes were their prime status symbol. Not only must they be in the proper style inside and out, but they also must be filled with the latest domestic technology. They also were museums to display the family's accomplishments, travels and artistic taste. Thus, their eclectic interiors and exteriors were often cluttered and often in several interior décor and architectural styles. The Victorians were both masters and victims of conspicuous consumption long before moderns coined the phrase for the concept.

Proper people wore the proper clothing for every activity at every time of day: morning clothes, tea clothes, evening clothes, promenading clothes, coaching clothes, bathing clothes, yachting clothes, tennis clothes, golf clothes and dancing clothes. Women, themselves prime status symbols for their men, were especially impacted, donning nearly a dozen outfits a day at a resort like Cape May, each featuring layer upon layer of garments, all of which were designed for fashion, not comfort, practicability or health. While displaying their sartorial taste, they were simultaneously notifying both the general populace and their peers that they had the leisure time and wealth to afford to do so.

So, too, proper people spoke, nay conversed, properly. Here was a chance again to display not only one's social graces but also one's education, culture and cosmopolitan awareness. A Victorian would never use a single-syllable word when one with multiple ones could be substituted. They never used a simple sentence when a complex compound one could be crafted. In writing, it was a golden era for the one-sentence paragraph. Again, these were status displays, displays of one's being able to afford an advanced education and of having the time to be well read and well traveled.

If moderns were able to ask Victorians about all these shows of status and their obsession with same, they most likely would deny it. As with so much of their lifestyle, they had a much more genteel rationale for their behavior: they were actually performing a social service for their society.

The Victorian Cult of Domesticity

The Victorian man's home was truly his castle. It was his oasis of civility, a haven of refuge, providing comforting contrasts to the ruthless rigors of the laissez-faire business world, a place of reward and renewal. Here, he and his family enjoyed the spoils of earnest striving toward ever-greater material abundance and social status. Here, his vassals (servants) pampered him and guarded the drawbridge (entrance hall) against unwanted intruders (callers) into his physical and social world. Here, in his home and his lifestyle within it, he displayed his hard-won status, his position of substance and respectability.

The Victorian wife and mother was the chief icon within this temple of respectability. Victorian men developed a virtual cult of domesticity, placing their wives and mothers on pedestals, to be protected and pampered. Only a modern cynic might note that these ladies were also status symbols of success and virtue. By being a dutiful husband, the Victorian man added another dimension to his virtue. According to prevailing Victorian philosophy, his wealth, being a gift from a pleased God, had assured his virtue. The Victorian man's care of his wife and family enhanced his virtuous image. Again, only a modern cynic would point out that his era was also a golden age of prostitution and that supporting a mistress was also an almost expected status symbol. After all, he was obligated to care for his family first, never endangering their well-being by expenditures and indiscretions involving his mistress.

This cult of domesticity and concern with an image of proper family life had its roots with Queen Victoria herself. She came to the throne with a personal and political need to restore the virtue and resultant credibility of the royal family after the debaucheries of a series of her male relatives and predecessors. So infamous had been their personal behavior that the continued value of the royal family as symbolic leaders of England and the empire was seriously in question in the 1830s. Added to Victoria's motivation was Albert's Germanic properness about family. When the royal couple grew to deeply love each other, duty soon became genuine devotion.

Thus, for a complex variety of reasons, the Victorians evolved their cult of domesticity. Wives and mothers were viewed as embodying all that was good about humanity: nurturing, artistic, sensitive, compassionate and loving. These virtues, plus the fragility of body and emotions that men felt accompanied them, obligated Victorian men to provide for their women

and protect them. To a Victorian man, the only person more perfect than his wife was his mother. He placed them both under a glass bubble and on a pedestal for all to behold and appreciate. If his ability to provide for and protect them so magnificently within his castle/home further enhanced his own self-esteem and social status, this was simply his just reward for his own superiority and virtue.

Horatio Alger's Stories Illustrated Victorian Views

Alger wrote over one hundred books of varying length and with varying settings and characters but all with the same rags-to-riches theme. His works were always bestsellers during the 1870s and 1880s, as Victorians apparently never tired of the repeating plot, which both reflected and reinforced so many Victorian views and values.

In each of Alger's books, an honest and industrious lad with latent talents, through his merits and perseverance and a little luck, seizes upon his opportunities to rise to affluence and respectability. Heroes like Tattered Tom and Ragged Dick, each so popular they had their own series, perfectly exemplify earnest striving upward as they lived and personified the American dream. The Victorians saw in these stories their own stories or what they hoped their own stories would be.

The titles of Alger's books depicted their hero's road to success: *Brave and Bold, Slow and Sure, Strive and Succeed*. Most involved poor, usually fatherless, lads with the vital prerequisites of honesty, morality and latent ability achieving success, riches, influence, reputation, honor and self and community esteem via their industriousness, prudence, temperance, punctuality, courage and perseverance. Since God favors such individuals, chance and luck inevitably assisted these worthy lads in their earnest striving upward. Skeptical moderns are reminded that many, but certainly not all, Victorians experienced a dramatic increase in their standard of living and socioeconomic status during the Victorian era. This was especially true of the newly created middle class. The Industrial Revolution gave such people material goods beyond imagination a generation earlier, along with the disposable income to purchase them and the leisure time to enjoy them. This was certainly true of those resorting to Cape May.

One wonders if Affluent Tom and Rich Dick ever stayed at Congress Hall, the Chalfonte, the Columbia House or the Colonial. While rocking on

the porches of the Stockton, Lafayette or Arlington between promenades and bathing upon the strand, they would undoubtedly have been enjoying a Horatio Alger novel.

Resorting to Cape May

Why did Cape May become so popular a location for vacationing during the Victorian era that it was known as the "Queen of the Seaside Resorts"? Why was it also known that "everybody who is anybody" resorted at Cape May? The answers can be found in a serendipitous combination of geography, economics, sociology and philosophy that combined to make the resort at the confluence of the Atlantic Ocean and Delaware Bay so attractive to the Victorians.

Economically and socially, a whole new class of newly rich Americans had been produced by the Industrial Revolution: the middle class. Mainly the middle managers of industry, small businessmen and newly esteemed professionals such as doctors, scientists, lawyers and engineers, they had more money and leisure time than their parents ever dared dream of for them. For the first time in history, wealth was not solely tied to hereditary landownership. Upward socioeconomic mobility, and its accompanying wealth and status, was now a realizable and often realized American dream come true.

The prevailing philosophy of the Victorian era circumscribed limits on what one could do with one's wealth and leisure. The Protestant work ethic held that God rewarded the hardworking with favor and wealth. Idle leisure time was fertile with the devil's dangers. The Victorians' concurrent belief in social Darwinism led them to believe that their prosperity was proof of their evolutionary superiority. Yet with superiority came an obligation to lead one's society and to set proper examples according to the age-old aristocratic philosophy of noblesse oblige. Wealth and power brought with them incumbent social responsibilities.

To reconcile these cultural imperatives, the Victorians used their new leisure time and disposable income to make themselves even better in spirit, mind and body, to recreate themselves by religious, educational and fitness activities. Thus, they would become even more pious, powerful and profitable. Recreational activities must be contrasted with amusements, which had little or no religious, educational or physical value. Thus, religious revival meetings, educational Chautauquas and exercise were

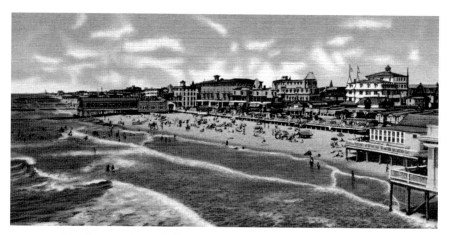

A general view of Cape May, including the beach and boardwalk. *Courtesy of the Cape May County Historical Society.*

godly and good, while gambling, dancing and spectator sports were devilishly evil.

Enter geographic factors favoring recreating at Cape May. Industrialization's urbanization had made cities increasingly perilous to one's physical and spiritual health. Smoke, sewage and sin seemed to be spawned by them at an alarming rate. Locales purer in physical and spiritual environments must be found. To improve oneself, one must resort to leaving the cities to recreate. Located within reasonable travel time of the growing East Coast cities of Washington, Baltimore, Philadelphia and New York was pristine Cape May. Its peninsular position made access by sailing schooner and steamship simple. Who would want to ride over the almost literally bone-breaking carriage roads or new railroads when one could skim over the waters in comparative comfort? Once here, resorters could recreate themselves in the almost constant salty breezes and moderate climate whether upon the strand or sea, promenade or porches. In addition, during the early 1800s, "taking of the waters" via ocean bathing became popular among trendsetters. Cape May's wide, hard-packed, gradually sloping beaches were ideal for this. What better calmatives and restoratives from the stresses of both the cities and their leadership responsibilities could Victorians seek? Since only people of the finest sort resorted to Cape May, one's moral and intellectual as well as physical recreation was assured. Once a place like Cape May became popular among trendsetters, the status-conscious newly rich were sure to flock there "to see and be seen."

Is it any wonder, then, that everybody who was anybody resorted to Cape May to recreate themselves, making it the Victorian Queen of the Seaside Resorts? As long as overland transportation and amusements remained frowned upon, fortune must surely continue to shine on Cape May.

The Two Reigns of the Queen of the Seaside Resorts

G iven its location at the tip of a peninsula on the Atlantic coast, it's logical that the sea would shape Cape May in many, many ways. Some have been obvious but some more subtle. Throughout its history, Cape May has been a city both by and of the sea, rich in maritime heritage.

Cape May was named for a sea captain, Dutch explorer Cornelius Jacobsen Mey, and its first permanent European settlers were mariners, whalers from New England and Long Island in the 1670s. It had been discovered in 1609 by another explorer sailing for the Dutch, Henry Hudson. For centuries prior to these events, Native Americans had come to the cape for their version of seaside summer vacations.

When the first English settlers, who came by boat, soon found that there were not enough whales in the Delaware Bay to sustain them all year round, they turned to the sea for solutions. These Pilgrim descendants became fishermen and Delaware Bay and River pilots. The relatively mild climate and long growing season caused by the moderating influence of the surrounding waters was a major factor in the success of their other economic activity, farming.

Its position as co-guardian of the entrance to the Delaware Bay and River, along with its twin Cape Henlopen, added tales of pirates and wartime perils to Cape May's early history. In the early 1700s, pirates, especially Edward Teach (aka Blackbeard), came to the cape to replenish their fresh water from Lake Lily and perhaps bury treasure there.

Blackbeard often sailed up the Delaware to enjoy the company of one of his many mistresses, one Margaret (some say her last name was Trollop, but that seems too good to be true), at Marcus Hook, Pennsylvania. Onshore, the cape's infamous mooncussers would lure ships onto the shoals of the rips and then plunder them. They used false beacons to imitate the lighthouse and could only do so on foggy, cloudy nights. Thus, they cursed the appearance of the moon, leading to their nickname. During both the American Revolution and War of 1812, the British also sought fresh water at Lake Lily while American privateers found safe harbors in the many bays, coves and inlets of Cape May. During the latter war, patriots repulsed landing parties along the bayshore but were stopped from firing on British landing parties at Cape May by one Abigail Hughes, probably saving the tiny village from a destructive naval bombardment. At Cape May Point, intrepid patriots fouled the fresh water of Lake Lily by digging a trench to the bay, allowing salt water to flow into it. During the American Revolution, a small naval battle was fought near Turtle Gut Inlet (at today's Rambler Road in Wildwood Crest) just north of Cold Spring Inlet, the entrance to Cape Island Creek and Cape May's tiny harbor.

Cape May's greatest fame came as a Victorian seaside resort during the 1800s. Geography, climate and transportation preferences, all maritime related, combined to produce these golden economic years. Ocean bathing and inhaling the salt air became popular vacation activities in the 1800s, an escape from unhealthy city life. Resorters came by boat to the landing near today's Sunset Beach and were then transported by trolley or light railroad along the coast to Cape May or by carriage or coach overland via Cape Island Turnpike (today's Sunset Boulevard). Once at Cape May, they spent most of their daylight hours either "promenading the strand" or "bathing in Neptune's Realm."

Cape May's harbor for its fishing fleet was along Cape Island Creek at Schellinger's Landing. Access was via a narrow, winding creek through the marshes to Cold Spring Inlet on the Atlantic. It was totally inadequate for the transport of masses of summer visitors or for their recreational needs. Still, Cape May, the city both by the sea and of the sea, boomed as a maritime-centered resort.

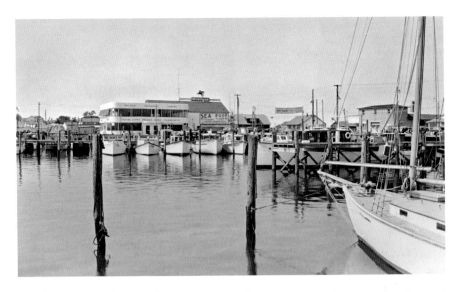

Cape May Harbor. *Courtesy of H. Gerald MacDonald.*

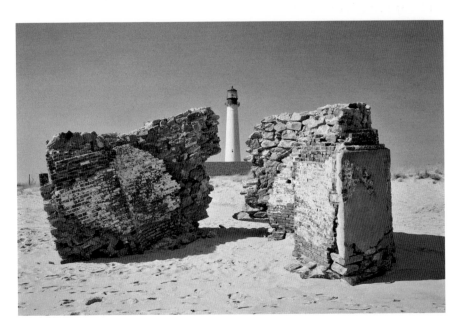

Cape May Lighthouse (1859) viewed through the foundation ruins of the 1847 lighthouse. *Courtesy of the Library of Congress.*

Cape May—A Seafaring and Fishing Tradition for Over Three Hundred Years

Located at the tip of the twenty-mile-long peninsula with which it shares its name, Cape May quite logically has a rich maritime heritage. This location, in the middle of the mid-Atlantic region where the Delaware Bay meets the Atlantic Ocean, has for over three hundred years been the prime attraction of Cape May, be it for fishing or enjoying a day at the beach and in the surf. Cape May's relatively mild climate, caused by the surrounding seas and a surprisingly southern location nearly fifty miles below the Mason-Dixon line at the latitude of Washington, D.C., enhances its attractiveness for vacationers.

Long before Europeans came to the cape, Native Americans migrated here each summer, attracted by the same pleasant climate and bountiful fishing that continues to be a major draw for tourism today. These were a branch of the Delaware known as the Lenni-Lenape.

Fishing and relaxing on the beach are only parts of Cape May's maritime heritage, which also includes whaling, pirate tales, shipbuilding, wartime adventures, yachting and use of the sea as the preferred luxury way to travel. The first European settlers of Cape May were whalers from New England and Long Island in the latter part of the 1600s. They settled at Town Bank along the bay. They were Pilgrim descendants, and their thirty-five families were the main local residents here until the mid-twentieth century, when they were joined by an ongoing flood of retirees. Cape May County has the highest percentage of Pilgrim descendants in the nation outside New England. Soon these first permanent settlers found they could not sustain themselves by whaling in the bay alone, so they became fishermen, farmers, shipbuilders and Delaware Bay and River pilots, beginning a tradition among locals that continues today.

Cape May has its tales of pirates and buried treasure. Captain Kidd and Blackbeard are said to have prowled offshore and even come ashore for fresh water at Cape May Point's Lake Lily and to bury treasure. We do know that a black sheep son of the longtime local Hand family served with Blackbeard, lending credibility to this pirate lore.

During the American Revolution and War of 1812, British warships and landing parties menaced Cape May as well as the entire region. Here they came ashore for fresh water and for cattle and other foodstuffs. During the War of 1812, one local legend has patriots digging a mile-long ditch to foul Lily Lake with seawater, while another tells of a woman wisely preventing the firing of the local cannon at the British by placing herself in front of it

and refusing to move. One wonders what destruction the return fire of the British ships might have caused and also just how ardent the local militia was for battle if they opted not to move the lady aside. Cape May was also a haven for privateers, especially during the American Revolution. Privateers were in a sense legalized pirates, private ships authorized by the government to prey on enemy shipping.

While it hosted some summer visitors for fishing in the late 1700s and early 1800s, Cape May's first golden age coincided with the Victorian era. The Victorians began building "summer cottages" here in addition to large hotels. Many still stand as attractions for modern tourists. Soon, in addition to "bathing upon the strand" (swimming at the beach) and "promenading the town" (walking around the streets, beach and boardwalk), the Victorians were enjoying yachting and fishing trips "taking full advantage of the joys of Neptune's Realm." During the Victorian era, it was said that "everybody who was anybody came to Cape May," and they came by boat.

A trip to Sunset Beach today gives the visitor a chance not only to view the remains of the sunken concrete ship *Atlantis* but also to collect Cape May diamonds. The *Atlantis* is a remnant of an unsuccessful attempt to establish a ferry line to Delaware during the 1920s, while the very semi-precious quartz pebbles that were a favorite of the Victorians can be found in profusion at the shoreline. Besides these two aspects of Cape May's maritime heritage, visitors will also often get a view of the modern ferries cruising to and from Delaware. This ferry line was established in 1964, adding another chapter to the Cape May seafaring saga.

A key to safe maritime travel and another important part of Cape May's seafaring heritage is its lighthouse. It stands as a stately sentinel at the northern entrance of the Delaware Bay, warning mariners of the treacherous rips nearby while welcoming them to the bay. The current one is at least the third and was built in 1859. It is open for touring and climbing regularly.

It was during the late Victorian era, the first decades of the twentieth century, that the Cape May Harbor of today took form. Prior to that, ocean mariners used the typically narrow (for South Jersey) Cold Spring Inlet to come into Cape Island Creek and the main docks at Schellinger's Landing. In the early 1900s, in an effort to boost Cape May's declining tourist trade, a grandiose plan was developed to turn the hitherto undeveloped east end of the town into a resort for the super rich. It was to be the "New Jersey Newport," featuring a mammoth luxury hotel, the estates of the wealthy and a yacht club and golf club. To accommodate the yachts of the wealthy, a vast new harbor, basically the one visitors see today, was dredged out and the soil

used as landfill to make the marshland of eastern Cape May buildable. Two huge jetties were built at the inlet to the harbor, making it one of the safest on the coast. While overall the project was a failure in the short term, these harbor improvements would be a key to Cape May's renowned prosperity later in the century, facilitating an extensive sportfishing and commercial fishing industry.

The Cape May Canal, connecting its harbor with the Delaware Bay, was built during World War II. During both world wars, Cape May's new harbor hosted a naval base. Between the wars, it became a coast guard base, with one of its main missions to halt the extensive rumrunning going on in the area during Prohibition. During World War II, Cape May played a vital role in national defense as a guardian (along with Cape Henlopen) to the entrance to the Delaware Bay and River with its vital oil refining, shipbuilding and munitions plants upriver. Thus, another chapter was added to Cape May's rich maritime heritage. Fort Miles, which guarded the entrance to the bay, spanned both capes and was the most heavily fortified place per square mile along the Atlantic coast. Parts of these fortifications remain in Cape May today in the forms of a coastal artillery bunker near the lighthouse and two associated battery fire control towers, one amidst the Grand Hotel in Cape May and one near Sunset Beach.

Today, Cape May is enjoying a second golden age. It also maintains its rich maritime heritage. It is the home of the only U.S. Coast Guard basic training facility in the nation. It is again one of the most popular resort destinations on the Atlantic coast. Since the mid-1900s, it has become a leading commercial fishing port, ranking fifth in the nation in a recent report. It was also recently named one of the top sportfishing spots in the nation. With relatively easy access to both offshore canyons and the famed fish-rich "rips" where the bay and river meet, it has been a Mecca for party boats and sportfishing for over a century. Today, it has the largest and best-equipped charter fleet in New Jersey. Its numerous harbor-side marinas offer services and amenities for boats and boaters of every type. Ashore, visitors can relive the charms of the Victorian era via a variety of tours, historic sites and special events and can enjoy a rich variety of shopping and fine dining. They can opt to enjoy both ocean and back bay sightseeing cruises. And there's always swimming, surfing and kayaking at the beach.

As in the Victorian era, it is again said that everybody who is anybody is coming to Cape May, and many are again enjoying the pleasure of coming by boat, sampling and savoring the rich maritime tradition of Cape May.

Steam Service Was Vital to Victorian Cape May's Prosperity

Steamboats played a vital role in establishing Cape May as the Victorian Queen of the Seaside Resorts. Most of the 1800s was an age of travel by boat. Overland travel on the unpaved roads by horse or carriage was tortuous and dangerous and took the better part of two days from Philadelphia. Using the early railroads was faster (about six hours) but equally uncomfortable and dangerous. Those who could possibly do so traveled by boat, first sailing ship and then increasingly by steamboat.

Cape May's location was ideal in this era of water travel. It became the northernmost southern resort and the southernmost northern resort, serviced by both oceangoing vessels and via the Delaware River and Bay. The sloops, schooners of the early 1800s, were replaced by steamboats.

As early as 1816, Captain Wilmon Whilden's side-wheeling steamer *Delaware* was bringing resorters from Philadelphia and New Castle, Delaware, to a crude landing somewhat north of today's Sunset Beach. The New Castle stop was for passengers from Baltimore and Washington,

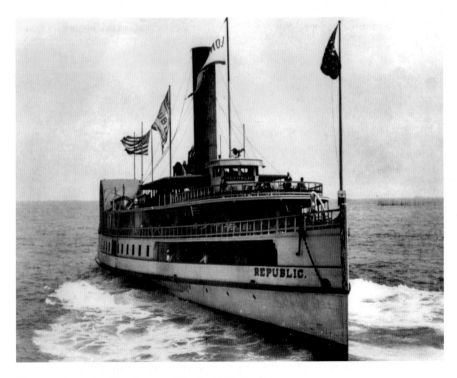

The steamboat *Republic*. *Courtesy of H. Gerald MacDonald.*

D.C. By 1830, he had established a better dock at the end of Cape Island Turnpike (today's Sunset Boulevard), complete with a "comfort cottage" known as the Delaware Bay House. Other steamers of this time were the *Vesta, Traveler, America* and *Stockton*. The bayshore was the only logical landing locale rather than through the ocean surf or at Cape May's then tiny harbor on narrow, shallow, winding Cape Island Creek at Schellinger's Landing. Schellinger's was home for small fishing and recreational craft and was known locally simply as "the landing," while the bayshore locale was known as "the steamboat landing." By the 1850s, steamers from New York were making the twelve-hour trip for one dollar. Those from Philadelphia took six hours and cost fifty cents.

The golden age of steamboat travel to Cape May was also the era of the famed SS *Republic*. From 1878 to 1903, Jonathan Cone's luxury "palace steamer" reduced the time for the trip from Philadelphia to five hours traveling at a brisk fifteen knots. For one dollar, this iron, three-decked side-wheeler offered up to 2,500 passengers a day a dining hall serving three meals, a pair of elegant public salons, two private parlors, ten staterooms and ongoing entertainment from an orchestra and the diminutive Commodore Doyle, "the world's smallest sailor." It was the ultimate in elegant travel. Resorters were then transported to Cape May via omnibuses and coaches along Cape Island Turnpike or via trolley and light rail along the coastline around Cape May Point.

By the 1880s, however, railroad and trolley travel had improved in comfort and safety and offered even quicker access to Cape May. The trip from Philadelphia averaged three hours, making a new type of resorting possible: the day trip. The railroad had first come to Cape May in 1863 in the middle of the Civil War. In 1894, a second line was completed. Suddenly, resorters' transportation preferences were changing. Cape May's peninsular position, so long an advantage in an era of water travel, now became a disadvantage in an era of overland travel. Resort locales such as Atlantic City, more quickly reached by rail, began to prosper at Cape May's expense. The crown of the Queen of the Seaside Resorts was threatened, mainly because of railroad travel.

Railroads Had a Mixed Impact on Cape May's Prosperity

Railroads and their cousins, trolleys, were a second major transportation improvement of the 1800s. Their impact on Cape May was much more mixed—sometimes positive, sometimes negative.

The railroad first reached Cape May during the Civil War in 1863. This was almost a decade after it reached Atlantic City in 1856. The West Jersey Railroad was a subsidiary of the powerful Pennsylvania Railroad. Its line ran near today's Routes 55 and 47 along the bayshore before ending at a station on Jackson Street where Swain's Hardware Store is located today. During the 1870s, a junction was added at Ocean View for service to the barrier islands. By 1868, summer resorting traffic had grown enough to necessitate a second Summer Station accompanied by the Sea Breeze Excursion House at Grant and Beach Avenues. The latter offered accommodations and amenities for a new type of resorter, the day tripper. Viewed condescendingly by cottage owners and hotel patrons who stayed for extended periods of time, day trippers were said to bring only a bathing costume and lunch in a shoe box. Thus, the name and legend of the Shoobies was born.

The West Jersey Railroad strongly promoted tourism and resorting in Cape May. In 1868, it built the mammoth Stockton Hotel, whose property

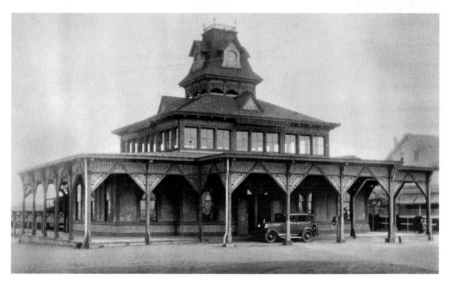

Grant Street Summer Railroad Station. *Courtesy of H. Gerald MacDonald.*

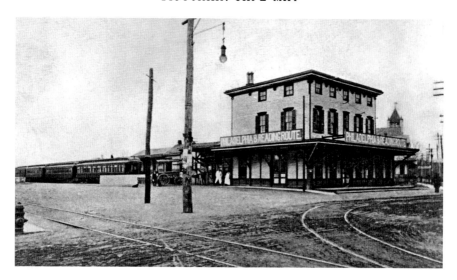

Combined Washington Street railroad station. *Courtesy of H. Gerald MacDonald.*

extended from Beach to Columbia Avenues and Gurney to Stockton Streets. It also offered "improvement tickets" or free passes to anyone building a cottage in Cape May. It would do the same to help the town rebuild after the Great Inferno of 1878.

The 1880s saw the building of both trolley and light rail lines from the bayshore steamboat landing along the coast around Cape May Point and then along Beach Avenue around Sewell's Point to Schellinger's Landing. Eventually, this Delaware Bay, Cape May and Sewell's Point line became a subsidiary of the West Jersey/Pennsylvania Railroad. In this instance, the rail lines helped the steamboats prosper. Eventually, rail would surpass them. Railroads reduced travel time to Cape May to hours and ran more frequently than steamboats.

This same decade saw the establishment of trolley lines along Ocean and Washington Streets.

In 1894, the rival Reading Railroad began competing with the Pennsylvania for the growing overland seashore traffic in the form of its South Jersey Railroad. Its line ran parallel to today's Atlantic City Expressway and then south down the Jersey Cape with a junction at Tuckahoe. Soon, spurs ran to each of the new offshore barrier island resorts that had developed from the late 1870s through the 1890s primarily because of rail service. The South Jersey station in Cape May was on Ocean Street between Washington and Lafayette Streets.

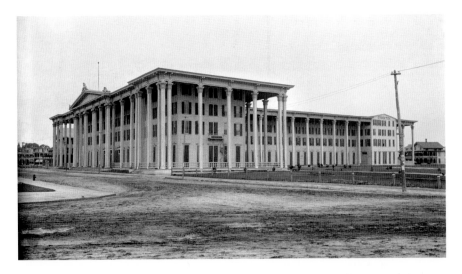

The Stockton Hotel. *Courtesy of the Library of Congress.*

Thus, the 1890s saw two rival lines, the West Jersey and the South Jersey, running down either side of Route 9 to Cape May. Often, trains would race each other to Cape May. The rivalry turned ugly, with fighting between rival construction crews at Woodbine where the South Jersey attempted to cross the West Jersey's right of way. The courts decided an overpass should be built for the South Jersey to solve the conflict. Eventually, the rivals would merge into the Pennsylvania–Reading Seashore Lines in 1933 to better deal with a newly emerging transportation rival, the automobile.

By the end of the Victorian era, the railroad had replaced the steamboat as the main way of traveling to Cape May and the rest of the South Jersey seashore resorts. As overland travel came into favor, Cape May's peninsular position that was so advantageous in the previous age of water travel was now a handicap. It took too long to get here. The railroads spawned rival resorts from Atlantic City southward that were all easier and faster to travel to than the tip of the Jersey Cape. The first one of these, Atlantic City, born in 1856, would usurp the crown of the Queen of the Seaside Resorts. The later rise in popularity of improved automobile travel over greatly improved roads exacerbated Cape May's decline. Just as the railroads had surpassed the steamboats, automobiles then surpassed the railroads.

Not until its Victorian renaissance of the 1970s would Cape May's crown be restored. Neither steamboats nor railroads would play a significant role in this return to prosperity.

Erecting Enormous Elephants

There were three of them in the region—enormous elephants erected on the beach at Coney Island, Margate and, of course, Cape May. Only Margate's remains. The construction of an "elephantine colossus upon the strand," to use the Victorian phrase, was unique to the era, with each being constructed in the early 1800s. Why?

Such curiosities arose because of the confluence of several socioeconomic forces. It was a time of free enterprise, laissez-faire capitalism when the entrepreneur and entrepreneurial spirit reigned supreme. The nation was just emerging from a downturn in the economic cycle, so optimism was again in bloom. Cape May's elephant, officially "the Light of Asia" but nicknamed "Jumbo" by locals, was erected in the South Cape May Meadows as part of a real estate development venture by Theodore Reger to attract prospective clients to the curiosity and area.

Why an elephant as an attraction? The answer was partly the emergence of the popularity of amusement parks and circuses, with many of the latter featuring elephants. Elephants were viewed as especially exotic and appealed to the fascination of Victorians with exotic cultures and civilizations, which had been stimulated by the wildly popular expositions of the era. The newly emerging advertising industry was quick to exploit this popularity for business purposes.

Lest one think this fascination with the foreign was a manifestation of a reduction in Victorian ethnocentrism, we should be aware that the cultures of Asia and Africa were in vogue because they were viewed as primitive and a refreshing escape from the sophisticated and advanced culture of the Victorians. Thus, the Victorians' adaptation of Afro-Asian elements in interior décor, attire, literature, arts and architecture was cultural condescension. It also allowed affluent Victorians to display their cosmopolitan worldliness.

Why an elephant in particular? To the Victorian mind, elephants were a symbol of India, and India was the crown jewel of the British Empire and the showpiece of imperialism. In 1876, Prime Minister Benjamin Disraeli had Queen Victoria named Empress of India to gain her support for his colonial expansion policies. Not only did he gain her support, he also lifted her from her prolonged mourning period for Prince Albert. Victoria became fascinated with things Indian, and what was in favor with the Queen was soon in favor with Anglophiles on both sides of the Atlantic Ocean.

Facilitating the spread of "India-mania" and real estate ventures such as Theodore Reger's was the shrinking of the Victorian world by

improvements in communication and transportation. Most important were railroads. They dramatically increased the ease and speed of travel. In combination with the telegraph, steamboat and improvements in photography, foreign cultures became more and more readily accessible to the increasing number of affluent Victorians. Access to Cape May improved concurrently.

Thus, a confluence of many socioeconomic forces combined to produce enormous elephants on the beachfronts in our region. They were placed there to trumpet Victorian culture and enterprise. By the end of the era, the Light of Asia was but a memory. Today, only Margate's Lucy remains as a fascinatingly unique artifact of a fascinatingly unique era.

Boardwalks Began in Cape May during Victorian Era

Early Victorian resorters to Cape May loved bathing on and promenading along the strand. The wide, gradually sloping beach was ideal for the pleasures of recreating oneself by taking of the healthy waters and salty sea zephyrs. The hotels that lined the strand during the 1850s such as the Atlantic, the Congress Hall and the Columbia House lured their guests here by touting these pleasures and their proximity to them. While they loved all the vacationers, they hated all the sand they were tracking into their lobbies upon returning from the strand. The hotels' bathhouses eliminated this problem for most bathers but not for promenaders.

The solution to this sandy pollution was boardwalks. The first ones were developed in America's First Seaside Resort and were just that—walkways of wooden boards. These boards were temporarily laid for the summer season across the sand from the high tide line to each hotel's lobby entrance. As guests walked across them—which was much easier than struggling with the soft, dry sand—most of the sand fell from their boots. These walkways of wooden boards were perpendicular to the ocean.

Soon, enterprising merchants noted that these boardwalks funneled potential customers to and from the beach. Temporary stands and shops began to appear along them.

The Civil War (1861–65) temporarily interrupted tourism, but by the late 1860s, resorting and the business of accommodating resorters were returning to normal.

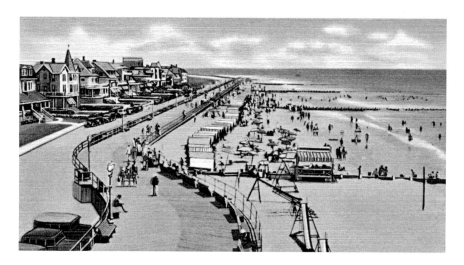

Cape May beach and boardwalk. *Courtesy of the Cape May County Historical Society.*

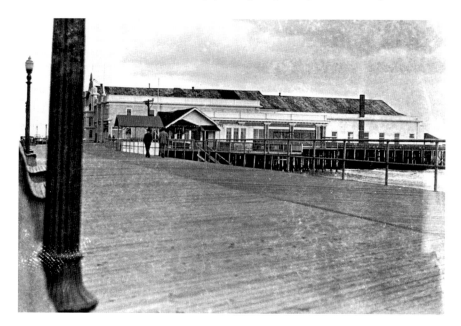

The Cape May boardwalk, photographed by Isaac Zwalley. *Courtesy of H. Gerald MacDonald.*

The business and governmental leaders of Cape May had noticed that once resorters were strandside, they promenaded parallel to it. Why not build a permanent boardwalk strandside parallel to the ocean connecting the temporary perpendicular ones? Promenaders could enjoy the strand

to one side and the magnificent homes and hotels to the other side while simultaneously shopping and improving their health. Thus, the first permanent parallel boardwalk was born in Cape May in 1868, just as the first temporary perpendicular ones had been created in the 1850s.

Atlantic City's boardwalk appeared two years later in 1870. That resort also erected the first raised boardwalk several years later. Soon, shops of all sorts and amusement piers lined these boardwalks. By the end of the Victorian era in the early 1900s, almost every seaside resort had some sort of boardwalk.

Ironically, the town where boardwalks began now doesn't have one. After the last of several was again destroyed by a storm in 1962, it was replaced by today's protective seawall and given the name "promenade" as part of Cape May's Victorian renaissance—a renaissance built on the era in which the first boardwalks were built in Cape May.

The Dreaded Fire Demon

In language as ornate as the homes in which they were read, Victorian newspapers were filled with accounts of "the hot breath of the Fire King," of "fingers from Hades reaching" to draw human and structural victims "into the inferno" of "tongues of the Fire Demon lapping around" buildings and of "the tentacles of the Fire Demon encircling" another victim. Fire was an ever-present danger in the Victorian world. Nowhere was its effect felt more than in Cape May.

The Victorian world was a highly combustible one. Cities were largely composed of wooden structures built close together. These were largely lit by gas and heated by coal. It was a world of open flames and flying embers. Faulty early electrical wiring added to these dangers. Outside, steam engines spouted more glowing embers into the air. All about were scattered smoldering cigar butts and wooden matches. The interiors of Victorian buildings were also filled with combustible materials. Even more highly combustible was Victorian clothing, especially that of women. The bulkiness of their layers of clothing made contact with fire more probable, and the dyes used in them made them even more flammable. One routinely reads of women bursting into flames with deadly results.

Once fire erupted, inadequate water delivery systems, equipment and technology made the task of Victorian firefighters Herculean. In coastal

towns, such as Cape May and Chicago, steady strong winds made their task almost impossible.

The "dreaded Fire Demon" was an all too familiar unwanted visitor to Victorian Cape May. In 1856, the almost completed Mt. Vernon Hotel, reputed to be the world's largest, burned to the ground on the west end, never to be rebuilt. The same fate befell the Mansion House and adjacent Kersal Music Hall a year later.

In 1869, a major part of the business district erupted in flames. Eventually, an area bounded by Beach Drive, Washington Street, Ocean Street and Jackson Street was in ashes, including the Old Atlantic and United States hotels. Only a wind shift prevented more destruction. Arson was suspected but never proven. The "incendiary" was alleged to be one Peter Paul Boyton, known locally as "the Pearl Diver" and owner of a novelty shop on Washington Street of the same name. A hero for his many surf rescues, he was also notoriously unstable.

"The Great Inferno" engulfed Cape May in early November 1878. It began in the Ocean House on Perry Street across from Congress Hall. Again, an incendiary was suspected, this time Ocean House owner Samuel Ludlum, but while circumstantial evidence convinced the citizenry of his guilt, it was insufficient for a court conviction. Nearly forty acres burned, reducing almost the entire business and hotel district to ashes. The area of destruction was bounded by Beach Drive, Gurney Street, Congress Street and an irregular line encompassing parts of Washington and Hughes Streets and Columbia Avenue. Eight major hotels, two thousand bathhouses and numerous businesses and private and guest cottages were lost. Miraculously, no fatalities occurred. Hotels destroyed included the Ocean House, Congress Hall, Centre House, Old Columbia House, New Atlantic, Knickerbocker, Merchants and Denizot's Sea View Cottage.

In 1889, the New Columbia Hotel fell victim to fire, and only the city's upgraded firefighting equipment prevented more destruction. The same was true of the blaze that consumed the Marine Villa and a few nearby cottages at Howard Street and Beach Drive in 1903.

The most noted fire victim of the twentieth century was the Windsor in 1979, which was located west from Congress Hall on the beachfront. As in Victorian times, locals suspected arson, and many still do to this date, but the allegation and identity has never been proven.

Lest we be accused of myopic provinciality in our study of Victorian fires, we should be aware of two that made much more of an impact nationally than any of Cape May's. In 1871, most of Chicago burned in

perhaps the nation's most famous fire. As in Cape May, wooden, closely packed, gas-lit and coal-heated structures were involved, and a strong wind off Lake Michigan fanned and spread the flames. Here hundreds died and over 100,000 were left homeless. Over three and a half miles of the city were incinerated. Of almost equal infamy was the fire at the Triangle Shirtwaist Company's facility in New York City in 1911, in which 146 workers, mostly women, died inside this sweatshop whose doors had been locked by management lest the workers sneak out for unauthorized breaks. The building had no fire escapes or firefighting equipment. Public revulsion at the tragedy provided major momentum for efforts to improve industrial working conditions and the general treatment and status of workers. The existing government–big business alliance's efforts to minimize the disaster provoked public demand for additional reform and regulation, sparking the careers of future U.S. senator Robert Wagner and future New York governor and presidential candidate (1928 against Herbert Hoover) Alfred Smith.

No consideration of the role of fire in Cape May's history would be complete without mention of the erection in 1984 of the city's fire museum. A recreation of a Victorian firehouse that once stood at the site at Washington and Franklin Streets, it serves as a tribute and reminder of the valiant ongoing efforts of generations of firefighters to vanquish "the dreaded Fire Demon."

The Pearl Diver's Fire of 1869

The largest and most destructive fire in Cape May's history, the Great Fire of 1878, was known to Victorians as the Great Inferno. The second most serious fire was in 1869. Using typically flowery Victorian language, "the breath of the dreaded Fire King ignited our fair community on August 31 just at the end of the summer resorting season."

The "Pearl Diver's Fire" was said to be started by Peter Paul Boyton, known locally as the Pearl Diver, in his Oriental goods and novelties shop on the south (ocean) side of Washington Street between Ocean and Decatur Streets. Boyton (known as Boynton in Cape May) was an atypical character famed as Cape May's best Victorian lifeguard who went on to a spectacular career as an aquatic daredevil and amusement park entrepreneur of international renown. It was also speculated that the

fire was an attempt by jealous provincial locals to drive an odd outsider who was ruining their lifesaving businesses out of town and that their incendiary efforts got out of control.

Abetted by the historically combustible combination of wooden buildings built close together and an ever-present peninsular wind, the flames quickly spread from his Washington Street shop to the nearby massive United States Hotel at Decatur and Washington Streets. Soon, several other shops in what was then and remains Cape May's business district along Washington Street were ablaze. The fire was contained to the south side of the street but spread oceanward, engulfing many resorters' cottages. The flames continued to spread, or, as the Victorians wrote, "then in sheer wantonness, the Fire Fiend made a flanking movement blowing his heated breath" on both the Atlantic Hotel on the beachfront and the American Hotel on Decatur Street. Eventually, most of the area from the south side of Washington Street to Beach Avenue and from Ocean Street to Jackson Street was a smoldering ruin. Only the massive Columbia House hotel was saved by the heroic efforts of both firefighters and townspeople. It would not survive the next fire in 1878. In a preview of the later fire of 1878, Cape May's understaffed and under-equipped fire department proved totally inadequate to meet the challenges of a major fire.

There were three more fires in 1856, 1857 and 1889. All were in single hotels; two were in the off-season. Two were probably unproven arsons.

The Return and Redemption of Peter Paul Boyton

Among the plethora of phantasms abounding about Cape May in the Halloween season is an old acquaintance with a new name and reputation: Peter Paul Boyton, aka Peter Paul Boynton, aka the Pearl Diver.

Those who recall him remember an eccentric character from the 1860s who was perhaps the Queen of the Seaside Resorts' most famed lifeguard and most infamous incendiary (that's Victorian for arsonist). He was heretofore known as a mysterious character who was such a skilled swimmer that he was often hired by local hotels and/or resorters as their private lifeguard in those days before a municipal beach patrol. Said to have come to Cape May after a career as an adventurer and pearl diver in the South Pacific, he also was proprietor of a souvenir shop located on Washington Street, part of the town's business district that was the predecessor of our modern mall.

In 1869, he was said to have started a fire in his failing shop that quickly spread into the second most disastrous fire (after the Great Inferno of 1878) in Cape May history. Much of the business district and the United States, new Atlantic and American Hotels were lost in the blaze. Boyton was run out of town and Cape May history by angry citizens.

However, thanks to the research of local historian Emil Salvini, the Pearl Diver has returned with a new name and reputation.

Peter Paul Boyton, from Philadelphia via Ireland, was a twenty-one-year-old with a taste for adventure and excellent swimming skills. His parents had an Oriental goods store in Philadelphia with a branch in Cape May that he managed. He was also a highly skilled lifeguard. He was a veteran of the Union navy during the Civil War. His Cape May experiences were but a minor footnote in his life.

After leaving Cape May, he served as a volunteer in European armies before returning to the Jersey Shore in Atlantic City as head of the United States Life-Saving Service there, a position of great responsibility and esteem. There he met C.S. Merriman, who had developed an innovative vulcanized rubber suit with air bladders that allowed its wearer to stay buoyant almost indefinitely. Combining the suit with his swimming skills and adventuresome spirit, he quickly gained international fame as a sort of aquatic Evel Knievel, performing sensational daredevil feats. In both Europe and then America, he broke several swimming records, including crossing the English Channel and Straits of Gibraltar, in addition to several rivers and the canals of Venice during the 1870s.

In the 1880s, he returned with his daredevil rubber-suited act to America. Here, he added lectures about his exploits to his repertoire and became a millionaire celebrity. The 1890s found him running two amusement parks on Coney Island, New York, with himself as the featured attraction. He is credited with inventing the concept of the amusement park in America. Salvini calls Boyton "a cross between P.T. Barnum and Buffalo Bill."

The real Peter Paul Boyton was far from the infamous character portrayed by Cape Mayans. For more on him, refer to Salvini's recently revised edition of *Summer City by the Sea* and his article in the July 2013 edition of *Cape May Magazine*.

The true tale of Peter Paul Boyton has a plot all too familiar in Cape May. Outsiders who don't fit the personality and lifestyle mold of centuries of intermarried and provincial locals can be ostracized. Perhaps we can coin a name for this reaction and process; "outlanders" are often "Boytonized" by hard-core locals who even get their name wrong, giving

it a peculiar local distortion. Their role and value in the community can also be distorted.

I hope to encounter the redeemed spirit of Peter Paul Boyton one Halloween season. I suspect the real truth of his time in Cape May is one of jealous, provincial and interrelated locals suspicious and angry at an "outlander" who was both of a "different sort" and hurting their own private lifeguarding businesses. As to the fire of 1869, perhaps in the rich tradition of unproven Cape May arsons, it was a local incendiary's attempt to burn him out of town that got out of control. It was a good cover-up to run the irksome outlander out of town. If you encounter his apparition, first ask him and then let me know—telepathically, of course.

The Great Inferno of 1878

November 9 is a date Cape Mayans would like to forget but never will. It is the date of perhaps the most infamous and destructive event in Cape May history: the Great Fire of 1878. It was better known as the Great Inferno to the Victorians who summarized it thusly: "the dastardly Fire Demon grasped Cape May in its deadly tentacles threatening to squeeze the very life out of our fair community." This description is typical of ornate and emotionally embellished Victorian writing. It may also have been influenced by a Halloween emotional hangover. Still, it seems somehow better to me than the modern "Cape May had a big fire that almost wiped it out."

Cape May was to suffer many fires during the Victorian era. Cape May during the 1800s was a fire waiting to happen with wooden buildings built close together; lots of open flame from wood, coal and gas fires; and an ever-present peninsular wind to spread the flames. Add to this situation a valiant but underequipped and under-funded fire department and a growing local predisposition to arson, and you have a highly combustible situation. All the major fires started conveniently in the off-season. Thankfully, only one (1856) resulted in casualties.

The Great Inferno started at the Ocean House Hotel across Perry Street from Congress Hall. Its owner, Samuel Ludlum, was noted hurriedly leaving town on a train just before it was discovered. Most locals suspected Ludlum of being the incendiary who started the blaze for insurance purposes in his failing establishment, but this was never

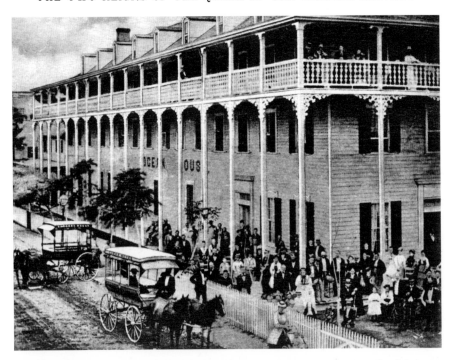

Ocean House Hotel, where the fire of 1878 first started. *Courtesy of the Cape May County Historical Society.*

A vintage Cape May fire engine. *Courtesy of H. Gerald MacDonald.*

proven legally. Cape May's Civil War hero Lieutenant Colonel Henry Washington Sawyer, then owner of the Chalfonte Hotel, first alerted town officials to the fire. His hotel would eventually be spared. The flames quickly got out of control and roared across the street to engulf the original Congress Hall. Driven by a seasonally typical brisk northwest wind, they spread from there to the Centre House Hotel on Washington Street and the Merchants Hotel on Jackson Street. As bucket brigades lined from the ocean were overwhelmed and rotted fire hoses burst, the fire raged out of control, soon consuming all of Jackson Street from Washington Street to Beach Avenue. In its path, many private cottages, small business and strandside bathhouses were consumed. Next, the New Atlantic Hotel and Denizot's Sea View House on Beach between Jackson and Decatur fell to the fire.

Help arrived by train from Camden in the form of new pumper fire engines and more trained firefighters. Still the Great Inferno roared on. It next claimed the Columbia House hotel spreading between Decatur and Ocean Streets, along with more private cottages and small businesses, including a shooting gallery and bowling alley. The bathhouses of the New Atlantic and Columbia Hotels were also lost.

Aided by additional fire equipment from Camden, the fire's spread was finally contained along Washington, Columbia and Gurney Streets by late afternoon. The inland side of the Washington Street business district, the massive Stockton Hotel and the Stockton Row Cottages and John McCreary House, as well as the cottages along Columbia Avenue, were saved. So was Dr. Ware's drugstore at Columbia and Ocean. Ironically, Samuel Ludlum's cottage across the intersection was also saved.

The tentacles of the Fire Demon had destroyed seven hotels, three dozen cottages, numerous small businesses and two thousand bathhouses over thirty-five acres from Congress Street to Gurney Street and from Beach Avenue inland to an irregular line along Washington Street and Columbia Avenue. The heart of Cape May's hotel and business district was a pile of ashes and ruin that smoldered for two more days.

After the fire of 1878, blame for the inadequacy of Cape May's firefighting equipment and understaffed and under-trained fire department became a hot topic for local political firestorms, with Republicans and Democrats each blaming the other for the disaster. Some things never change.

Eventually, the fire department was upgraded, and Cape May rebuilt itself and its reputation. By the early 1880s, the Congress Hall had been rebuilt, as had the Columbia House and Denizot's Sea View Hotel and the

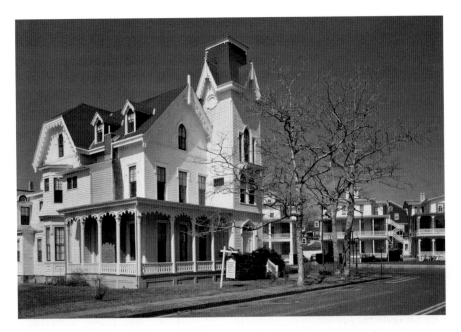

The McCreary House, spared from the fire. *Courtesy of the Library of Congress.*

new Windsor and Lafayette Hotels along the oceanfront. The Washington Street business district was also rebuilt. Cape May had overcome, if not tamed, the Fire Demon...at least for a few years.

The Fire Demon Menaces Cape May

There's nothing like a warm, cozy fire to comfort oneself on a blustery November day. This section is about three fires that menaced Victorian Cape May that were catastrophic rather than cozy and comforting. These three "unwelcome visits from the dreaded Fire Demon" took place in 1856, 1857 and 1889. In those years, "the tentacles of the Fire Demon wrapped" first the Mt. Vernon Hotel, then the Manson House Hotel and lastly the New Columbia House Hotel "in their fiery embrace." The imaginative and dramatic Victorian language used to describe the fires is set off with quotation marks.

Victorian Cape May was a combustible city with the dangerous combination of wooden buildings built close together, lots of open flames

from wood and coal fires and gaslights, a steady peninsular wind to spread any blaze and an inadequately equipped, trained and funded fire department. Add to this the local tradition of arson (always unproven), and you have a formula for "the dreaded Fire King frequently blowing his incendiary breath on our fair community."

The first of Cape May's major fires broke out in the newly built Mt. Vernon Hotel near the beachfront and Broadway Avenue in 1856. Said to be the world's largest seaside hotel at the time, it sprawled over ten acres (including grounds and auxiliary buildings) and was able to accommodate over two thousand guests. The four-story structure included a bowling alley, shooting gallery, archery range, barbershop, "palatial" salons and a dining room that could seat three thousand. Just after the summer season drew to an end, on September 5, it burned to the ground in an hour and a half, killing its owner, Philip Cain, four of his children and an employee. This was the only fatal major fire in Cape May. Firefighting efforts had been few and futile. Arson was suspected. A disgruntled former employee was felt to be the incendiary, but this was never proven.

The Mt. Vernon fire established a disturbing pattern for fires in Cape May during the Victorian era. Most were in the off-season, most were likely unproven arson and most found the local fire department overmatched.

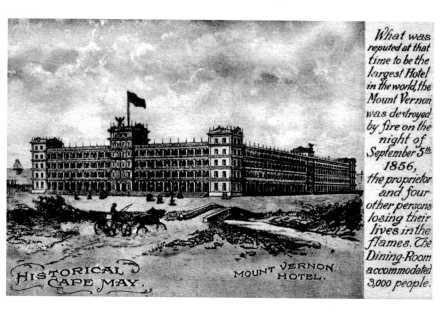

Mount Vernon Hotel, destroyed by fire in 1856. *Courtesy of the Cape May County Historical Society.*

One year later, in 1857, the Mansion House Hotel and its Kersal annex, a ballroom and concert hall, received an unwelcome visit from the Fire King, who was seemingly intent on the ruin of the Queen of the Seaside Resorts. Located on Washington Street between Jackson and Perry Streets, it was the town's largest hotel at any time. The complex burned to the ground in a few hours. Again, arson was suspected but never proven. Again, firefighting efforts were too little and too late. The fire broke the pattern of suspicious after–summer season fires, occurring in June. Ironically, the Mansion House's owner was Richard Ludlum, whose son Samuel eventually relocated to the Ocean House on Perry Street across from Congress Hall and was generally suspected to be the unproven incendiary of that establishment, which spread into the Great Inferno of 1878.

The Fire King breathed once more on Victorian Cape May in 1889. The victim was the New Columbia Hotel, built on the location of the previous one at Washington and Ocean Streets that had been destroyed in the 1878 fire. Built of "fireproof" brick, it erupted in flames on September 25 (again when it was conveniently empty after the summer season). Having finally learned to respect the Fire King, Cape May had a much improved fire department by 1889 that was able to contain this blaze to the hotel only. A gas explosion, not arson, was found to be the cause of "the Fire Demon's tentacles."

Cape May seems to have tamed the Fire Demon since the Victorian era. Its fire department is now first class. Fire prevention awareness is a first priority. You can enjoy your cozy, comfortable fireplace without fear of feeling "the Fire King's incendiary breath."

Well...there was that suspicious fire in 1979 that destroyed the Windsor Hotel at Windsor Street and Beach Avenue, which was by then empty and unprofitable. Hmmm...the Fire King and local incendiary tradition both die hard.

Fearsome Female Fire Fatalities

As another service to the ladies of Victorian Cape May, I offer the following warnings about the increasing numbers of these fair creatures who are falling victim to the dreaded fire demon, whose flaming fingers all too often embrace them with fearsomely fatal results. Ladies, innocents that you are,

you are no doubt unaware of these perils that endanger you. Hardly a week passes that one does not read or hear of a hapless woman bursting into flame. Please read on and take heed.

The fashionable frocks and other items of female finery you so pleasingly grace our vision with also make you a walking incendiary. Your layers of unmentionable undergarments are constructed of extremely inflammable materials. So is your frock. Its inflammability is exacerbated by many of the new dyes that give it such attractive colors. Its billowing shape greatly widens the circumference of your contact with the world around you both at home and about our fair city.

As you innocently traverse our Victorian world, the fingers of the fire demon lurk everywhere. At home and in hotels, restaurants and public halls, burning embers from fireplaces and stoves and flames from open candles and gas and oil lamps threaten to make you an immolation to the Fire God. Heedless of your safety, alleged gentlemen scatter the embers and remains of their cigars carelessly about, even on the floors of carriages. The locomotives of the railroads spout forth a volcano of glowing ashes to imperil you.

If the Queen of the Seaside Resorts could fall victim in 1856, 1869, 1878 and 1889 to the fearsome fire monster, how much more vulnerable are you, milady, in your daily life, to the fatal flaming fingers of this fiend? Please take precautions with your person. Gentlemen, it is incumbent upon you to remain ever vigilant and ever stalwart in protecting our ladies from these perils.

The Stressful Summers of Cape May's Common Folks

Amidst the images of the self-proclaimed proper people properly enjoying ocean bathing, dining, dancing and entertaining one another during the summers in Victorian Cape May, it's easy to forget that almost all of the town's year-round residents were common folks, people of the middling or lesser sort in Victorian terminology, and that it was these folks who made the opulent resort life of the upper classes possible. They did the work so that the visitors could relax. Summer was an especially stressful time for them.

The Victorian summer resorting season lasted two months: July and August. It was during these months that common Cape Mayans

worked doubly hard, for what they earned during the tourist season often determined whether the year would be one of prosperity or deprivation, feast or famine, financial make or break. Living at the subsistence level for ten months, these two months determined if they could improve their lifestyle above that level.

Most locals were commercial fishermen, farmers, small merchants or river and bay pilots. With the exception of the pilots—and even their business increased during the summer with more ships sailing here—all the rest engaged in some aspect of the hospitality and tourism business each summer.

Fishermen became charter or party fishing boat captains or captained sightseeing excursion boats. Some opened bait and tackle shops, also at "the Landing" (today's Schellinger's Landing). Those who remained commercial fishermen hoped for larger sales to hotels and restaurants.

Young laborers in Cape May, 1909. *Courtesy of the Library of Congress.*

Local homes became summer cottages rented to visitors, with the owners moving to more spartan quarters nearby. Others were only open in the summers, investment properties of local merchants. All of the grand hotels—the Atlantic, Columbia House, Congress Hall, Caroll Villa, Colonial, Lafayette, Marine Villa, Ocean House, Ocean Villa and Stockton—were only open during the summer season, each employing many local seasonal workers. The merchants of Washington Street hoped business boomed every summer then as now.

Many locals of all backgrounds found second jobs serving the summer visitors in the cottages, at their hotels or in the shops of Washington Street or as mates on boats at the Landing. The area's many farmers, like their fishermen friends and relatives (and in nineteenth-century Cape May, almost all locals were related to one another), hoped to sell more of their crops to the local hotels and restaurants or grocery stores.

While welcoming the increased business the summer visitors brought to town, locals did not enjoy the generally condescending and elitist attitude they also brought with them. Victorian social philosophy promoted the concept that those who were economically inferior were also socially and indeed evolutionarily inferior also. In Victorian thinking, the middle- and upper-class summer visitors were of the better sort, more virtuous and respectable than locals who were mainly lower class or at best lower middle class and thus of the lesser or meaner sort. These locals were common people, and common was one of the most derogatory terms a Victorian of the upper classes could use.

Beyond such condescending attitudes were even more dramatic and stressful distinctions. Often upper-class Victorians signaled to rather than spoke to lower-class individuals. Proper Victorians avoided mixing socially with lower-class common folks. Beaches were segregated economically as well as racially. Those near the center city hotels and resorting cottages were for proper visitors. Most locals and other lower-class bathers were limited to the western and eastern ends of the town or the bayshore. This practice is one reason why Cape May's eastern end became known as Poverty Beach. Ironic today, isn't it, what with many of our most expensive private homes located there?

In all interactions with the people of the better sort resorting to Cape May, local common folk were expected to act in a deferential way in both speech and actions. How galling this must have been. Yet the common folks needed the visitors' economic stimulus each summer.

Thus, both physically and psychologically, summer was a stressful season for the common folks of Cape May.

Reviewing the Parade of Victorian Presidents to Cape May

During the Victorian era, it was said that everybody who was anybody visited Cape May. Exhibitions at the Greater Cape May Historical Society's Colonial House offered abundant evidence to support this claim. Among the galaxy of stars from the Victorian universe to shine in Cape May were several presidents, former presidents and presidents to be. Consultation with the history books and sources at the Greater Cape May Historical Society and the Mid-Atlantic Center for the Arts produced a consensus that the following presidents have visited Cape May. These included Victorians Millard Fillmore, Franklin Pierce, James Buchanan, U.S. Grant, Chester Arthur and Benjamin Harrison. Non-Victorians included Andrew Jackson and Woodrow Wilson.

Cynics among us have been heard to note the similarities between a list of Cape May's Victorian presidential visitors and a list of those who are generally considered among the worst presidents by both historians and the general public. Weak is often a generous term applied to the presidential impact of these and many Victorian presidents. Notable exceptions include James K. Polk, Abraham Lincoln, Theodore Roosevelt and possibly Grover Cleveland. While there is considerable basis for such cynicism, we should validate our judgments with the tempering influence of historical perspective.

It is important to understand that the balance of power among the branches of government was quite different for most of our history than it has been from the Franklin D. Roosevelt administration (beginning in 1932) through today. The prevailing philosophy was that the legislative, not the executive, branch should dominate. The chief executive's job was viewed

William Henry Harrison. *Courtesy of the Library of Congress.*

Top: James Buchanan. *Courtesy of the Library of Congress.*

Left: U.S. Grant. *Courtesy of the Library of Congress.*

as that of administrator carrying out the laws Congress had made. Thus, strong congressional leaders dominated, with presidents appropriately weaker in comparison. Even Washington and Jefferson had endorsed such a relationship. A Jackson or Lincoln or Theodore Roosevelt was an exception.

Also important to understand is that from the downfall of the Federalists after John Adams in 1800 until the Civil War, the prevailing national political philosophy was that state governments should be more powerful than the national one.

Chester Arthur. *Courtesy of the Library of Congress.*

After the war, a third, powerful retardant to presidential power and prominence quickly evolved. This was the Republicans' adoption of the laissez-faire view of the relationship between government and the private sector. The Democratic Party had always held this position as part of its weak national government philosophy. Government's role was to allow business activities and the economy to function in an unhindered, natural, social Darwinist manner, free of government involvement and regulation. Whatever government economic activity took place

Benjamin Harrison. *Courtesy of the Library of Congress.*

was to promote business interests such as establishing a high protective tariff, ensuring sound money and suppressing the organizing efforts of labor.

Thus, we must understand that the role of the national government, and the executive branch of it in particular, was commonly felt to be much different than in the modern era of relatively powerful presidents. With this understanding we can view the parade of Victorian presidents who came to Cape May in the context of proper historic perspective as it passes by us.

Henry Clay in Cape May

Cape May called itself the Queen of the Seaside Resorts during the Victorian era. It was said that everybody who was anybody came here to see and be seen. This was never truer than in 1847 when Henry Clay resorted to Cape May.

Clay (1777–1852) was arguably the most famous and popular American of his age. His visit did much to enhance the resort's already great fame and reputation. Clay's oratorical and political skills had earned him a reputation as the Great Pacificator or the Great Compromiser. In an era when the legislative, not the executive, branch controlled the national government, Clay of Kentucky was part of the Great Triumvirate (along with Daniel Webster of Massachusetts and John C. Calhoun of South Carolina) that dominated Congress and thus national affairs. His was often the voice of compromise between North and South prior to the Civil War. His Missouri Compromise (1820) was typical of this. By the 1840s, he had already been elected to both the Senate and House of Representatives several times, been Speaker of the House several times, run for the presidency three times and helped to found the Whig Party. This is but a brief overview of the remarkable man. By 1847, he was very depressed, however, having lost his third bid for the presidency in 1844 and lost a son in the Mexican War, which he had vigorously opposed.

Thus it was in late July 1847 that Henry Clay began an East Coast tour whose ultimate goal was Cape May to "enjoy a sea bath which I have never in my life before had an opportunity of doing." Hopefully this "quiet trip" would help him recover from his son's death at the recent Battle of Buena Vista in the Mexican War (1846–48). Clay wrote of the trip, especially his time in Cape May: "I thought I would fly to the mountain top and

Henry Clay. *Courtesy of the Library of Congress.*

descend to the waves of the ocean and by meeting with the sympathy of friends obtain relief to the sadness which encompassed me." He traveled first to White Sulfur Springs, in the hills of what was then still Virginia, and then by rail to Baltimore and Philadelphia. From Philadelphia, he took a steamboat to Cape May, arriving on August 17. In Philadelphia, huge crowds of supporters mobbed the home where he was staying, demanding and receiving an inspirational and patriotic oration in the typically dynamic Clay style.

So popular was Clay, such a VIP, that it was impossible for him to travel anywhere quietly and unnoticed. A special steamer was chartered for him complete with a band. Delegations from New York urged that he visit that city, but Cape May was his goal.

When news of his impending arrival spread, well-wishers and politicians and media representatives flooded into Cape May from as far away as Washington, D.C., and New York for the chance to see, hear and hopefully speak with him. Henry Clay stayed at the Mansion House while in Cape May and spoke to an enthusiastic crowd at its Kersal Music Hall annex. After lamenting his son's demise and sharing his grief with his listeners, Clay vowed to "emerge from that theater of sadness" and noted how much "the kindest manifestations of feeling, manifestations of which at present a monarch or an emperor might well be proud," with which he, "a humble citizen," had been greeted had helped alleviate that grief.

Clay wrote of his frequent sea baths: "The air, the water, and the whole scene greatly interested me." Contemporary reports note that he "swam atop the breakers, dunking the ladies who dunked him in turn" and "frolicking like a man half his age" (seventy). Other reports had the ladies constantly asking for locks of his hair for their lockets to the point that he left town in mid-September with his previously normally long locks much shorter. Henry Clay also left Cape May with an even more glittering reputation as the Queen of the Seaside Resorts.

Returning refreshed to the national political scene, Clay was to author perhaps his most famous contribution to history, the Compromise of 1850, which most historians agree postponed the war between the North and South for another decade. His death in 1852 was marked with funeral observances on a scale not seen since George Washington's death and not rivaled again until the death of Abraham Lincoln in 1865.

The quotations of Clay cited in this section come from two sources: *Henry Clay, Statesman for the Union* (1991) by the eminent historian Robert Remini and Emil Salvini's *Summer City by the Sea* (1995).

Henry Washington Sawyer: Cape May's Civil War Hero

Cape May played host to several famous Civil War VIPs, including General Robert E. Lee, U.S. Grant and George G. Meade. Contrary to local lore, President Abraham Lincoln was not one of these guests. These famous figures notwithstanding, our local Civil War hero was Lieutenant Colonel Henry Washington Sawyer (1829–1893). Like most local Cape

Mayans, he was a common man but a common man of uncommon valor, virtue and accomplishments.

A native of Egypt, Pennsylvania, near Lancaster, Henry Sawyer migrated to Cape May in 1848 to earn his fortune as a carpenter, taking advantage of the Victorian-era building boom here. The better to blend into the local population, he changed his name from the original Saeger. Appropriately, both Saeger and Sawyer referred to being a carpenter. In a further attempt to blend into the local lifestyle, he married Harriet Ware Eldredge, who was descended from two leading local founding families. By 1860, he had established a reputation of as good a citizen as he was a carpenter.

With the outbreak of the Civil War in 1861, Sawyer zealously set aside his tools, family and comfortable lifestyle to volunteer for the Union army. His early service was as a representative to Washington for New Jersey governor Olden and as part of the hastily organized Cassius Clay Brigade guarding President Lincoln and the White House. This original, less familiar Cassius Clay was a noted Kentucky abolitionist.

Next we find Sawyer, a fine horseman and shot, as part of the newly organized First New Jersey Cavalry, where his natural leadership skills enhanced a rapid rise to captain. The valiant Sawyer suffered multiple wounds at battles at Aldie and Woodstock, Virginia.

After recuperating at Cape May, Sawyer returned to active duty in time to participate in the largest cavalry battle that has ever taken place in the Western Hemisphere at Brandy Station, Virginia, with eleven thousand Federals facing ten thousand Confederates in 1863. Sawyer was severely wounded and left for dead

Henry Washington Sawyer. *Courtesy of H. Gerald MacDonald.*

on the field. He survived and was sent to the infamous Libby Prison in Richmond, Virginia. It was while there that Henry Washington Sawyer morphed from a local to a national hero.

Cape May's Henry Sawyer became part of the infamous "Lottery of Death" and resultant prisoner of war exchange that involved yet another near escape from death and such notables as Lincoln, Lee and Jefferson Davis. While at Libby Prison, Sawyer was one of a pair of Union captains selected by lottery to be hanged in retaliation for the execution of two Confederate captains accused of spying in Kentucky. Sawyer himself had suggested the drawing of lots by the prisoners, and his was the first name selected, followed by John Flynn of Indiana. His letters home alerted his wife to his impending doom. His execution was postponed due to the intercession of Bishop Patrick Lynch, a close friend and advisor to Confederate president Jefferson Davis who came upon the execution squad and was informed by Flynn of their chance fate and that he had not been given last rites. Lynch, via Davis, had the execution postponed. In the meantime, Sawyer's politically well-connected wife had enlisted allies powerful enough to alert the Lincoln administration of his peril. Some contend she even gained an audience with the president. Lincoln and Secretary of War Edwin Stanton reacted swiftly to rescue Sawyer and Flynn. General W.H.F. "Rooney" Lee, son of Robert E. Lee, had been captured in the same battle. His execution was threatened in retaliation for the deaths of Sawyer and Flynn.

The most famous prisoner exchange of the war was quickly agreed upon. Sawyer, Flynn and General Neal Dow were exchanged for two Confederate captains and General Rooney Lee. It was militarily and politically an exchange of captains for captains and a general for a general. However, Sawyer and Lee were the main principals in the exchange, and it would not have occurred without the efforts of Sawyer's wife and influential relatives. To many Cape Mayans, it was an exchange of Sawyer for Lee.

After additional military service, during which he rose to the rank of lieutenant colonel, Sawyer returned to Cape May at the war's end in 1865 to a hero's welcome.

"The Colonel," as he was henceforth known, became Cape May's leading citizen and official representative, greeting VIP visitors and leading parades on his white charger. Entering the hotel business, he quickly rose to the ownership of his own, the Chalfonte, in 1876. He served two terms on city council and was an ally of Dr. Emlen Physick.

He also became head of the state home for disabled soldiers and also of the New Jersey Life-Saving Service (ancestor of the coast guard). Sawyer was so esteemed that he was selected to arbitrate many local disputes out of court as "a man of good council." His decisions were accepted as undeniably just.

Henry Sawyer would live until 1893. He remarried after Harriet's death in 1889 to twenty-seven-year-old Mary Emma McKissick, thirty-three years his junior. It was he who alerted the town to the Great Fire of 1878. His funeral procession stretched completely from Cape May to Cold Spring Presbyterian Church. Among the many tributes to Henry Washington Sawyer, this one best summarizes his exceptional life: "He was a common man of uncommon valor, virtue and accomplishments."

I am indebted to the work of Dr. Clark Donlin and Bob Mulloch, two of Cape May's two leading experts on Henry Washington Sawyer, for much of the content of this section.

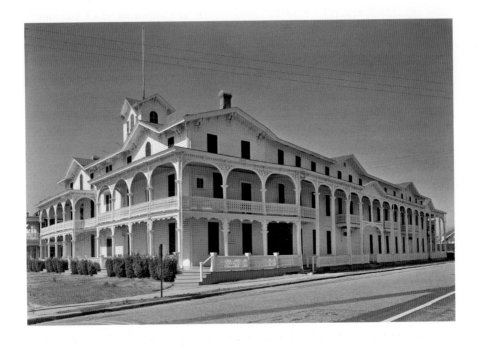

The Chalfonte Hotel. *Courtesy of the Library of Congress.*

John Philip Sousa in Cape May

No musician personified the spirit of the Victorian era in America better than John Philip Sousa. His biography reads like a Horatio Alger novel, and his music captured the effervescence, optimism, pride and patriotism of Victorian America.

The son of a member of the then second grade Marine Band, through a combination of hard work, talent and opportunism Sousa became the famed March King and the most famous bandmaster of the age. Via his world tours during the late Victorian era and into the 1920s, he became an international celebrity while raising American music to a level equal if not superior to any in the world.

John Philip Sousa first gained acclaim as a conductor of operettas, specializing in those of Gilbert and Sullivan. He then became leader of the U.S. Marine Corps "The President's Own" and soon made it truly the pride of America. Organizing his own civilian band during the 1890s, he drew the leading musicians of the age to it and soon made it the superior of any musical organization in the world. Beyond his famous marches such as "The Stars and Stripes Forever," "The Gladiator," "El Capitan," "The Washington Post," "King Cotton" and "The Liberty Bell," the Sousa band played the classics with equal skill, as attested by French musical icon Camille Saint-Saëns. "El Capitan" was the inspirational song of the Spanish-American War. The band of the USS *Olympia*, Admiral George Dewey's flagship, played it as the U.S. fleet steamed into Manila Bay to win a

The New Congress Hall. *Courtesy of the Cape May County Historical Society.*

John Philip Sousa. *Courtesy of the Library of Congress.*

decisive naval victory during the war. During World War I, Sousa was dubbed "The Pied Piper of Patriotism," a title he cherished as much as "The March King." Sousa also introduced and popularized American jazz in Europe. On both continents, Victorians marked Sousa concerts among the highlights of their lives.

Only about one-third of Sousa's music was marches. He also wrote operettas, popular music, suites and numerous transcriptions of existing works. He changed both the composition of bands and the format of marches to that which we know today.

Sousa authored several books and was a skilled trap shooter. He's in the hall of fame of the latter. He was also a champion for musicians' royalty rights and for music education in schools.

Sousa had extensive Cape May connections. He honeymooned here in 1880. In 1882, his band played at the grand reopening of Congress Hall, newly

rebuilt after the fire of 1878. This was the first engagement ever of the Marine Band outside Washington, D.C., and added to its new fame. This was the first outdoor concert ever illuminated by electric lights. He wrote the "Congress Hall March" in honor of the occasion. Sousa and his band returned to the area several times. They were an even more frequent attraction in nearby Atlantic City, playing on the Steel Pier and for what is today called the Miss America Pageant. Sousa penned a march entitled "The Atlantic City Pageant" for that event.

Just as America was striving for political, economic, military and cultural equality among the nations of the world during the Victorian era, so Sousa sought similar acceptance and acclaim for American music. He realized his lifelong goal just as his beloved nation rose to similar status.

I am indebted to Mid-Atlantic Center for the Arts Living History interpreter Rich Chiemingo for much of the insights on Sousa. Just as Sousa became the personification of America for the world, Chiemingo has become the personification of Sousa for Cape May. For readers interested in more on John Philip Sousa, I recommend *John Philip Sousa: American Phenomenon* by Paul Bierley.

The End of the Victorian Era

There is general historical consensus about why and how the Victorian era ended but less agreement about exactly when it ended.

When did the Victorian era end? Some historians given to literal thinking and strict interpretations say 1901, when the Queen died. Many others feel it ended in 1914 with the start of World War I, while an equal number cite that war's end in 1918 as the end of the era. After reading about the generally agreed to whys and hows of the demise of the Victorian lifestyle and culture below, each reader can decide on their own favorite finishing date. Overwhelmingly, historians feel the two major factors that brought the Victorian era to an end were the rise of progressivism and World War I.

Progressivism was a multi-faceted social, political, economic and philosophical movement. It aimed at reforming the flaws, as its advocates viewed them, of Victorian culture in each of these areas. It began during the 1880s in the media of the day (magazines, newspapers, books) and in academia, first gained national prominence under the leadership of President Theodore Roosevelt (1901–9) and gained supremacy during

the administrations of President Woodrow Wilson (1913–21). I'll try to make its complexity easier to understand by generalizations. The major instrument used to correct the era's perceived social and economic abuses such as monopoly, exploitation of the lower working class and control of government by moneyed oligarchs or plutocrats would be a national government with greatly expanded powers over the economy. This more democratic government was now to be controlled by an expanded electorate (which would include adult women) and represent their interests rather than being controlled by big business and big finance. Such actions were anathema to the Victorians' laissez-faire, social Darwinist, pro–big business philosophies and resultant policies.

A series of constitutional amendments and national laws symbolized the progressives' changes. The Sixteenth Amendment (1913) provided for an income tax to fund the expanded national government. The Seventeenth Amendment (1913) took the election of senators away from state legislatures and gave it directly to the people; the Nineteenth Amendment (1920) enfranchised adult white women. The Interstate Commerce Act (1887), Sherman Anti-Trust Act (1890), Elkins Act (1903), Hepburn Act (1906), Meat Inspection Act (1906), Food and Drug Act (1906), Federal Reserve Act (1913), Federal Trade Commission Act (1914) and the Clayton Anti-Trust Act (1914) all greatly expanded the role of the national government in American life "for the good of the people." Similar acts were taking place in Great Britain. All were decidedly anti-Victorian.

Just as progressivism came to power, World War I erupted. The carnage of the conflict literally killed most of the next generation of European Victorians. (The United States was only directly involved in major fighting in the last year of the war, 1917–18.) As horrendous as these deaths were, even more impactful casualties were the basic optimism, hubris and faith in progress and technological advancement that formed much of the philosophic core of Victorian culture. Every day in every way, things were not getting better and better. Far from solving human problems and advancing human civilization, industrial and technological advances were used by Victorians to slaughter each other (tanks, machine guns, airplanes, poison gas, etc.). Thus, the Victorians began to question themselves and their civilization, questions for which the progressives were eager to provide answers as outlined above.

By the 1920s, the United States and most of the western world had entered a new era. Historians came to call it the progressive era. The Victorian era had ended.

The New Jersey Newport: Cape May's Failed First Renaissance

As we bask in the multiple benefits of Cape May's current multi-dimensional renaissance as a resort, it can be easy to assume that this rebirth was both easy and inevitable. However, the visionary preservationists who led the initial efforts in the 1970s did so despite the failure of our first renaissance during the first two decades of the 1900s. Remember the East Cape May Project? Remember the Hotel Cape May? Remember Peter Shields and Nelson Graves? Remember the failed effort to turn the eastern end of Cape May into the New Jersey Newport? Perhaps we would like to forget Cape May's failed first renaissance.

As the twentieth century dawned, it was twilight time for Cape May. The Victorian Queen of the Seaside Resorts was about to die much like Queen Victoria (1901). The vacationing public's transportation preference had changed. Overland travel by improved railroads had replaced vacation voyages by sailing ship and steamboat. Cape May's location on the end of the Jersey Cape, such an advantage in the seafaring 1800s, had become a disadvantage in the railroading 1900s. Resorts easier accessed in terms of speed and safety, such as Atlantic City and then Ocean City and the Wildwoods, were replacing Cape May as favored vacation locations.

Cape May had already tried and failed to revive itself in the 1880s via the creation of South Cape May. Even erecting an enormous elephant as its centerpiece could not draw enough vacationers to what is now the Cove area.

Efforts at a rebirth shifted to the other end of town, east beyond Madison Avenue to Sewell's Point. Making a complex story short and simpler, a group of entrepreneurs led by Peter Shields (yes, that's his home at Beach and Trenton Avenues) formed the East Cape May Improvement Company/Cape May Real Estate with plans to turn that part of town into a resort for the super rich. They planned to create the New Jersey Newport there. Rather than an enormous elephant as its centerpiece, they erected what would prove to be an enormous white elephant: the Hotel Cape May, an eight-story, brick, fireproof luxury hotel. Around the hotel, the super rich would build their resort "cottages." For the first time in its history, Cape May would attract upper- rather than middle-class resorters since the latter had forsaken the Victorian Queen for modern seaside jezebels along the Jersey Cape.

Peter Shields House/Inn. *Courtesy of Mid-Atlantic Center.*

Nelson Graves House/Mission Inn. *Courtesy of Mid-Atlantic Center.*

The first problems to overcome were that the site of this proposed super spa was a swamp and that our current harbor at Schellinger's Landing along tiny meandering Cape Island Creek was grossly inadequate to host the yachts and large steamships the wealthy still used for resorting travel. Both

The Fun Factory. *Courtesy of H. Gerald MacDonald.*

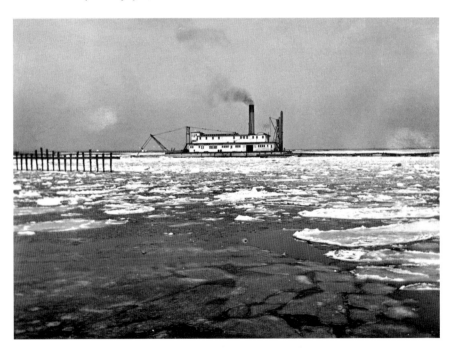

The dredge *Pittsburgh* creating the new Cape May Harbor. *Courtesy of H. Gerald MacDonald.*

Hotel Cape May photographed by Isaac Zwalley. *Courtesy of H. Gerald MacDonald.*

problems were overcome in one effort. What is now our spacious modern harbor was dredged out and the resultant soil used to fill in the swamps (the wetlands to you moderns).

To promote the New Jersey Newport and the Hotel Cape May, automobile races were held on the beach featuring Henry Ford and Louis Chevrolet. A new yacht club was founded on the harbor and a new golf club on Lafayette Street where today's elementary school is located. Later, a new amusement park, the Fun Factory, was founded at Sewell's Point.

Cape May built it, but they did not come. Financial problems and lack of an expected boom in private housing plagued the project. When bankruptcy threatened the Shields group, a new set of investors headed by Nelson Graves attempted a revitalization (yes, his home is today the Mission Inn on New Jersey Avenue near Philadelphia Avenue). This group added the Fun Factory to the attractions. Sadly, it, too, suffered bankruptcy.

By the entrance of the United States into World War I in 1917, it had become painfully obvious that this first Cape May renaissance was a failure. The Hotel Cape May had few visitors. Few, too, were the luxurious summer cottages in East Cape May standing in sad isolation amid a landscape of landfill. The Fun Factory would become part of a naval base built on the harbor during the war but burned down in 1918. Few of the planned grid work of streets named for states (in wishful imitation of Atlantic City) and cities were constructed. Most of the ships in the harbor left with the close of the naval base.

Gradually, a growing commercial and recreational fishing fleet would begin to use the harbor, as would a coast guard base. The land remained largely barren until the development of middle-class housing after World War II. The Hotel Cape May morphed into the Admiral and then the Christian Admiral. It would always remain a specter of the failed hopes for the New Jersey Newport until its demolition in the 1990s.

Only the Victorian renaissance begun in the 1970s would attract the boats and homes of the wealthy back to Cape May late in the century. This Victorian renaissance would realize the failed dreams of Cape May's Victorians for a resorting and resultant economic rebirth.

A Salute to Cape May in World War II

Navigating the water surrounding Cape May, one quickly notices them: the coastal artillery battery near Cape May Point ("the bunker"), the tall concrete fire control tower ("the lookout tower") near Sunset Beach, the coast guard base at the harbor's entrance and the canal leading from the harbor to Delaware Bay. Many know they are remnants of World War II; fewer know their story. Fewer still appreciate Cape May's vital role in homeland defense during World War II. Understanding and appreciating that role is the purpose of this piece. In retrospect, Cape May played a much more

important role in World War II than most people, including local residents at the time, realized.

Cape May and Cape Henlopen in Delaware had long been the twin sentinels guarding the entrance to the Delaware Bay and River. This protective role took on added importance during World War II. The German navy designated blocking the river and bay shipping as one of the, and perhaps the primary, strategic priorities along the Atlantic coast. By doing so, Allied forces would have been denied both the vital petroleum being refined upriver as well as the various vital craft being produced in shipbuilding facilities in the same area. Indeed, 50 percent of all the aviation gas used in Europe, North Africa and the Mediterranean came out of the Delaware Bay. Add to this the vital role of naval dive-bombers in winning the Pacific War and the role played by nearby Naval Air Station Wildwood in training their pilots. Add also the importance of anti-submarine patrols out of places like Naval Air Station Cape May in protecting vital Atlantic supply convoys and coastal shipping. The result is an increased appreciation of Cape May's important role during World War II.

Early in the war, there was great apprehension over not only German U-boat sinkings off the coast but possibly efforts by German airplanes and surface ships to block the entrance to Delaware Bay as well. There were even fears of an amphibious invasion. Little was known about German naval air power (it proved nonexistent), but much was known about the potential of its surface fleet (it proved moderately effective but no real threat to our coast). To protect the vital entrance to the bay, a complex of coastal batteries and observation towers named Fort Miles was constructed in 1941–42 by the U.S. Army. Over two thousand men were stationed there. The bulk of these fortifications were on Cape Henlopen since the ship channel is only a mile off it and thus twelve miles from Cape May.

Here in Cape May, a coastal artillery bunker was located near the lighthouse and two towers to control its fire in the Cape May area and two in Wildwood. The artillery bunker here has been exposed by extensive erosion and now stands surfside. One fire control tower is near Sunset Beach and the other encapsulated in the Grand Hotel on Beach Avenue. The towers in Wildwood have been torn down. Cape Henlopen has three batteries and eleven towers still standing. The Fort Miles towers were also used to spot enemy aircraft and submarines, but their primary purpose was to direct the fire of the coastal artillery. At the time, Fort Miles was the most heavily fortified place per acre in the United States and the best equipped. At Cape Henlopen, there were two sixteen-inch, four twelve-inch, eight

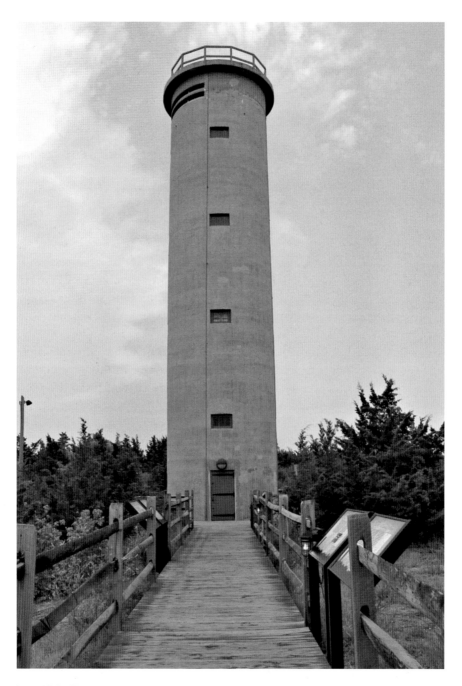

World War II lookout tower. *Courtesy of Mid-Atlantic Center.*

eighty-inch, four six-inch and numerous smaller guns. The Cape May battery contained two six-inch guns and eight smaller ones. The sixteen-inch guns had a range of over twenty-five miles. The guns at Cape May had a range from Avalon to Rehoboth Beach. Thankfully, none of these guns was ever fired at an enemy. In addition, the entrance to the bay was heavily mined. Four hundred to five hundred mines were controlled from Cape Henlopen using an early computer. This was reportedly one of the first uses of computers in warfare. Fort Miles was deactivated and its guns removed in 1945.

Many local residents served as air raid wardens and aircraft spotters throughout the area during the war.

Submarines turned out to be a much bigger menace in the area during World War II. Ten ships were sunk within a mile of the Jersey coast. One, the destroyer USS *Jacob Jones*, was torpedoed off Cape May in 1942 and was the first U.S. ship sunk after the attack on Pearl Harbor. Many more sinkings occurred farther at sea off the coast. A blackout was imposed to eliminate the silhouetting of ships by coastal lights. Even the Cape May Lighthouse went dark.

Naval Air Station Cape May was a key installation in the anti-submarine defenses in the area. While Fort Miles's primary assignment was surface ships, Naval Air Station Cape May focused on submarines. It did this with both ship and airplane patrols. The base had first been established during World War I. Between the world wars, it had become a coast guard base. The navy recommissioned it in 1940. The coast guard retained a small part of the facility during World War II devoted primarily to minesweeping and small, fast "mosquito boats" patrolling the bay. In addition to anti-submarine patrols, the navy also established communications research and training facilities at Cape May. The old Admiral Hotel (now gone) was requisitioned for use by the base as housing for officers and office space. It was the headquarters of the Delaware Bay Task Force and called the U.S. Naval Annex.

To facilitate access to the Delaware Bay for both navy and coast guard ships, the Cape May Canal was built from 1942 to 1943. The canal also allowed these military ships to avoid the treacherous rips off Cape May Point, lurking submarines at sea and the minefields between the capes when accessing the bay. It also was part of an inland waterway along the coast that allowed many merchant ships to avoid submarines offshore.

Rumors were constant about German submarines landing spies and saboteurs in the area. Various local legends tell of incidents of this, but no

definitive evidence was ever found. A major deterrent to such activities was mounted coast guard patrols along the beaches aided by dogs. These were common all along the coast. The Macomber Hotel at Howard and Beach was used to house the men of these patrols.

Rumors like the above—combined with an erroneous *Time* magazine article claiming local beaches were full of barbed wire, oil slicks and bodies—severely hurt the tourist trade, as did gas rationing. Cape May countered with a public relations campaign stressing the importance of vacations in keeping up morale. Its slogan was "V is for victory and vacations."

Also vital to the local economy then as today was the commercial and recreational fishing industries. Wartime restrictions, based on the danger from submarines and minefields, severely hurt them as well. Local legend and lore tells of fishermen encountering and being endangered by submarines. These tales, too, are unsubstantiated.

Another local contribution to the war effort was the Cape May Shipbuilding Company created at Schellinger's Landing to produce tugboats, ferries and other small craft for the war effort.

Ironically, the greatest damage to Cape May during the war years came not from the enemy but nature in the form of a horrendous hurricane in 1944. It wrecked the boardwalk and Convention Hall and caused $8 million in damage to the city.

Because of shortages caused by the war, the Northwest Magnasite Company erected a plant along Sunset Boulevard near the bayshore in 1942. It produced not only a product essential to the production of firebricks to line vital steel ovens and many jobs for local residents but also clouds of dusty white alkaline ash that often coated the surrounding area. It severely damaged the ecology of adjacent land. Thus, its closure in 1983 was not regretted by many. Today, only its water tower remains. Efforts are being made today to revitalize the environment in the area.

Naval Air Station Wildwood, opened in 1943, was an important training base for dive-bombers during the war. It was originally planned as a country airport before the war. Its first designation was NAS Rio Grande, but somehow this caused it to be confused with the Texas river and area of that name, thus the quick name change. At its peak, it was home for over 150 planes and nearly three thousand personnel. For brief periods, it also was used to train fighters and fighter-bombers, but its main function was training dive-bomber pilots. Practice runs were common sights over the wetlands, bay and ocean. Too common, also, were unfortunate crashes during training, with the loss of forty-one brave young men. In 1946, the base was returned

to the county, and it now serves as its airport and the location of an excellent aviation museum.

Cape May became the focus of national attention at the war's end when German submarine *U-858* surfaced and surrendered off its coast on May 14, 1945. The location was carefully planned to coordinate with the site of the previous sinking of the *Jacob Jones*. It was escorted to Lewes, Delaware, and its crew imprisoned at Fort DuPont, Delaware.

Thus, Cape May played a vital, under-publicized and thus underappreciated role in World War II. The restoration of Naval Air Station Wildwood into an aviation museum and the restoration of Fire Control Tower 23 on Sunset Boulevard into a World War II tourism site by the Mid-Atlantic Center (MAC) for the Arts and Humanities are important steps in correcting this oversight. MAC now offers a World War II trolley tour of many of the sites mentioned above and a World War II weekend in early June around D-Day. All these should serve as reminders of our nation's debt to the veterans of World War II and to stimulate within us a greater appreciation of them and for Cape May's important role in that war.

Next time you navigate past "the bunker," as we call the coastal artillery battery today, or past the fire control tower, or by what is now again a coast guard base, or through the canal, remember to salute them and those who served there. They helped us retain our freedom to enjoy the myriad maritime pleasures of Cape May today. Honor them with a hearty and heartfelt "well done!"

The Sea Still Shapes the Story of Cape May

It is noted that Cape May's, and the entire cape's, maritime heritage was both by the sea and of the sea. Logically for a locale on a peninsula, the sea has been the major factor in shaping our history and heritage. From its founding by and naming for sea captains and its early European settlers searching for whales in the 1600s, through pirate tales and early wartime activities and then the creation of the fishing and river pilot businesses of the 1700s to the tourism and seaside resorting of the Victorian 1800s, the sea has shaped life in Cape May.

Curiously, all this was accomplished with a very tiny harbor. Access to the sea was via small, shallow Cape Island Creek meandering through

extensive tidal marshes from Cold Spring Inlet (site of today's inlet) past Schellinger's Landing and thence beyond the town almost to the ocean again. The actual port was at what locals simply called "the Landing." Only small pleasure craft and commercial and recreational fishing boats could access it.

The dawn of the twentieth century brought with it the birth of the spacious harbor we enjoy today. It was created between 1903 and 1911, with additional deepening in 1913 as part of an effort to revitalize the fading popularity of Cape May as a resort. The middle-class core of Cape May's Victorian visitors now preferred overland travel by railroad and later automobile and were going to resorts with quicker overland access like Atlantic City. The upper class still traveled via their yachts. The new harbor and its safer entrance guarded by twin jetties was created to attract them to the equally newly created East Cape May area formed by landfill from the harbor dredging. The plan failed in the short term, but the harbor prospered as the 1900s continued.

Naval bases were created on Sewell's Point and just north of Cape Island Creek's connection to the harbor during World War I (1913–18), providing a greater, but still temporary, economic stimulus.

During World War II (1939–45), Cape May's role as co-defender of the Delaware Bay and River, together with its twin Cape Henlopen, again came into prominence. The towers and battery of our part of Fort Miles were constructed. The first U.S. warship sunk by enemy action after Pearl Harbor went down thirty-five miles off the cape, a victim of submarine torpedoes. It was the destroyer escort USS *Jacob Jones*. At the war's end, the first German submarine to surrender, *U-858*, was purposely directed to do so over the wreck of the *Jacob Jones*. This was an international news and media event. World War II also saw the building of the canal between the harbor and Delaware Bay. Between the wars, the Sewell's Point site had been a U.S. Coast Guard base.

Of more lasting effect, both on the local economy and lifestyle, was the growing commercial and recreational fishing fleet on the harbor, which expanded steadily from the 1920s onward. Today, Cape May ranks as one of the nation's leading commercial fishing ports and is also a world-renowned sportfishing Mecca. The canal has greatly enhanced recreational fishing by making access to the Delaware Bay quicker and safer.

The sea has not always been Cape May's friend. Throughout the years, a series of hurricanes and nor'easters has battered its beaches and buildings, the most serious being in 1944 and 1962.

THE TWO REIGNS OF THE QUEEN OF THE SEASIDE RESORTS

Beginning in the 1970s, the town of Cape May began experiencing its Victorian renaissance, which is ongoing today. It was sparked by the Mid-Atlantic Center for the Arts and a group of preservationist bed-and-breakfast owners. In 1976, Cape May became a National Historic Landmark city. Cultural heritage was now joining fishing, yachting and the beaches in attracting both tourists and permanent residents to Greater Cape May. Tourists again flooded to the city to enjoy its restored Victorian structures, as well as its beaches and harbor. This, in turn, further stimulated the recreational fishing and sportfishing activities out of the harbor. The dreams of the early twentieth century were fulfilled in its last quarter. The completion of the Garden State Parkway in 1957 and the Cape May–Lewes Ferry in 1964 also stimulated this resorting revival.

After World War II, the U.S. Coast Guard resumed control of its former base on the harbor from the navy. Today, it is the only basic training facility for enlistees in the nation. As such, it has become a vital part of the heritage and economy of Cape May.

A serendipitous influence of the area's seaside maritime climate has been the growth of an ever-expanding vineyard industry over the past few decades, adding another dimension to its attractiveness to tourists and vacationers.

Thus, just as in the Victorian era, Cape May today is the beneficiary of another positive perfect storm of attractiveness to tourism. This time, those attractions are even more multi-dimensional than in the 1800s, a combination of historic and new maritime ones. Cape May remains, more than ever, a city and area by the sea, of the sea and shaped by the sea.

The Crown Jewels of the Queen of the Seaside Resorts

Castles by the Sea

The adage "a man's home is his castle" was certainly apt during the Victorian era in Cape May. Here the Victorians built their castles by the strand, seaside retreats to resort to where they could rest and recreate themselves from the fierce competition of the unregulated Victorian business world with its daily Darwinian struggles to prove they could not only survive but prosper, thus proving themselves the fittest and most evolutionarily advanced of peoples.

These castles in Cape May, earned by the men's hard work and decorated inside and out by the women's sophisticated good taste, were so symbolic of an era of purposeful ornateness and ostentation, an era when more was by definition better and there was no such thing as too much, not just in architecture and interior décor but the entire Victorian lifestyle. When viewing Victorian buildings with their multiple styles, their towers, turrets, multiple porches, shingling like fish scales and shark's teeth and lacy gingerbread trim, all painted with a full palette of colors, one understands more about them when they are viewed as perhaps the Victorians' ultimate status symbol, their ultimate statement to the world of their elevated socioeconomic standing.

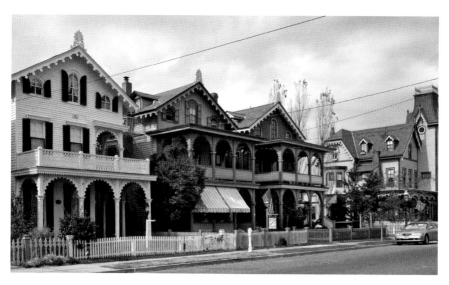

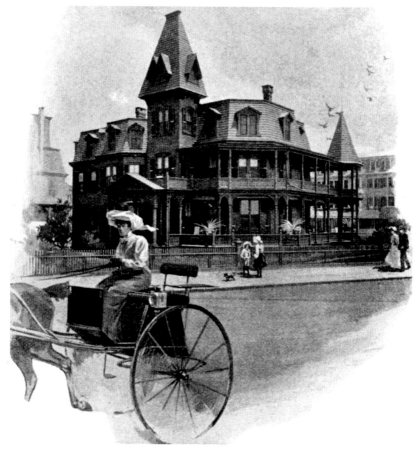

THE CROWN JEWELS OF THE QUEEN OF THE SEASIDE RESORTS

To arrive in Cape May, the Queen of the Seaside Resorts, was an announcement to the world that one had also arrived among the people of the better sort among the nouveau riche Victorians. To have a spectacular second home here was so much the better.

Cape May's castles by the strand were truly home, symbolic home, for the Victorians. To middle- and upper-class Victorians, one's home was a multi-dimensional symbol of all that they aspired to via earnest striving. It was a paramount expression of status, substance, respectability, sophistication and taste. It was a museum to display one's accomplishments and a castle offering refuge from both the rigors of a laissez-faire business world and the annoyances of interaction with those of "the lesser sort." The home was also the shrine of the cult of domesticity, a temple inhabited by the wife/mother goddess.

The floor plan of most styles of Victorian homes spoke volumes about the people who inhabited them and their lifestyle. Beyond an entrance hall where visitors were "screened" for admission was a honeycomb of separate rooms with specialized functions—a formal parlor, a family parlor/sitting room, a library, a dining room, a music room, a children's room, multiple guest and family bedrooms and multiple porches, not to mention servants' rooms clustered about the kitchen. Most of these had high ceilings, subtly indicating the family could afford not to worry about the effort and cost involved in heating them. Most were expensively and intricately decorated, indicating the family did not have to worry about the cost of currently chic items or the toil of keeping them clean.

The elaborately and extensively decorated public rooms contrasted with minimalist servants' room, reflecting the family's priority of impressing guests. In fact, even the family's own private rooms were usually not as lavish as the public rooms. In both public and family rooms, the basic Victorian interior décor philosophy prevailed—more was better, and there was no such thing as too much. The interplay of the vastly increased availability of goods, the vastly increased purchasing power of these families, the impact of the new advertising industry and the equating of status and respectability with wealth and the display of it produced the mania of conspicuous consumption manifested in Victorian homes.

Opposite, top: Victorian cottages, Cape May. *Courtesy of the Library of Congress.*

Opposite, bottom: The Weightman Cottage/Angel of the Sea Bed and Breakfast. *Courtesy of H. Gerald MacDonald.*

In both architecture and interior décor, Victorian homes were nothing if not varied. This was reflective of several forces shaping them, including a continuous succession of waves of style and the family's frenzied attempts to adjust to them and make proper display of their cosmopolitan sophistication.

In Cape May, these waves seem to have been delayed a decade or more before they washed upon the Jersey Cape. Also in Cape May, most homes were second homes or summer "cottages," no matter what their size. Such a designation was also an attempt to imitate the understated practices of the old money upper class.

While Victorian families were unquestionably (and largely unquestioned) paternal, benevolent dictatorships, Victorian men condescendingly deferred to their wives and mothers in matters of home décor and home entertaining. The home was the ladies' world, as they oversaw interior and exterior décor, family functions, entertaining, child rearing and the servants. Men, of course, retained the veto power over, and the financing of, these domestic matters. As long as the home and family reflected favorably upon the man's status and business enterprises, this power seems to have been little used.

Yet these unique structures with their intricate forms and colors somehow, in some perhaps meta-mystical way, seem in complete harmony with the equally varied forms and hues of nature around them—the ever-changing sea, sky, sands and pastoral scenes of Cape May.

As you travel through town, enjoy Cape May's unique collection of Victorian castles by the strand. As you do so, join us in giving thanks to those preservationists of the past several decades and today whose efforts have ensured that these castles have not been washed away by the tides of time and the temptations of shortsightedness.

Victorians' Homes—Shrine, Sanctuary and Status Symbol

To the Victorians, their home was a sanctuary, shrine and status symbol. It was their castle, their isle of domestic tranquility, the place to celebrate their success in the struggles of the socioeconomic battleground that was the world surrounding it. This was the man's refuge from those daily struggles, a place to retreat to, to resort to, to restore and reinvigorate himself for the next day's struggles. The home, too, was the woman's

place to shine, to display her domestic status. Second, seaside cottages, like those in Cape May, were even more so stress-relieving sanctuaries, places to recreate one's mental and physical health and to simultaneously show one's success and style.

These sanctuaries were also status symbols of the family's success in the ongoing struggles of life. They were hard-won private property within which to enjoy privacy from the teeming, tumultuous masses outside. They were in a very real sense large, highly visual trophies, symbolic of the family's socioeconomic, anthropological and moral superiority. Thus, their ornateness and their ever-changing styles were efforts to keep stylish and to outshine their neighbors' trophy homes. To have a second trophy home in Cape May could only enhance the esteem of the family in the eyes of both the public and themselves.

Victorian homes were also shrines from two perspectives. They were both the cathedrals of the Victorian cult of domesticity and centers of worship in an era when one's home tended to be as important a religious center as one's church. The Victorians daily thanked their benevolent God, who had favored them as his chosen elite. Fathers led devotions and read from scripture at meals. Mothers interpreted these lessons for their children, instructing them in "proper" theology and morality. Sunday services and family devotions were mutually reinforcing. No proper home was without some art or craftwork of a devotional theme. Resorting to Cape May meant the family had more time for devotions, a vital aspect of recreating themselves.

An important aspect of the enormously important trait of being "civilized" and "of the better sort" to the Victorians was to be domesticated. Family life was ideal life approaching heavenly life. The following quotes come from some books of domestic advice of the era: "The best homes are sanctuaries, wells of strength." "Remember that the home is an institution of God himself; it is his ideal of the life of humanity." "Heaven is a home; make homes on earth as heavenly as possible." And finally, "Women should strive to make a home something bright, serene and restful, a joyful nook of heaven in an unheavenly world."

Those Victorian families with summer cottages in Cape May thus counted themselves doubly fortuned and fortunate to have two family sanctuaries, status symbols and shrines.

Cape May's Victorian Architecture

The prime reason Cape May enjoys the status of a National Historic Landmark city is its rich collection of Victorian seaside architecture. Within a relatively small square mile area are found over six hundred beautifully preserved and restored examples of all styles of Victorian structures, including homes, hotels and public buildings. Not only are there multiple examples of the main Victorian architectural styles but also many fascinating mixed styles and several exotic styles.

The architecture and interior design of a culture usually reflects that culture's priorities, beliefs and lifestyle. This is certainly true in Victorian Cape May. The Victorians' prime status symbol was their home. Almost all Cape May homes were "summer cottages," second homes to resort to for recreation and amusement. Their existence was proof of a family's

Washington Street has remained largely unchanged since the Victorian era. *Courtesy of H. Gerald MacDonald.*

increased wealth, disposable income and leisure time. Resorting to one's Cape May summer cottage or to one of its fine hotels was visible proof of the family's wealth and resultant social status as people of, in Victorian terms, substance and respectability.

In a culture full of newly rich people obsessed with social status and materialism and displaying to the world their taste, cosmopolitan sophistication and wealth, the emergence of ornate, ostentatious homes full of the trophies of their success and artifacts proving their affluence was quite natural. Thus, there was the gingerbread appearance of so many Victorian homes and the wave after wave of the latest architectural styles currently in vogue. This yielded a city with not only a mixture of architectural styles but a city full of structures with mixed architectural styles, as additions in the latest style were added to existing ones to update them. Keeping current with the latest architectural and interior design styles and incorporating the latest technological developments, such as indoor bathrooms or electric lighting, was vitally important if said structure was to have its full impact as a status symbol.

To the Victorians, home sweet home was also home symbolic home.

Those interested in learning more about Cape May's Victorian architecture might want to consult *Cape May: Queen of the Seaside Resorts* by Thomas and Doebly. While a few items in it have been updated since its second edition in 1998, it remains an excellent source on the topic.

Waves of Victorian Architecture in Cape May

In their efforts to keep current with the latest trends in architecture and interior design—thus keeping their ultimate status symbols, their homes, appropriately impressive—the Victorians who resorted to Cape May rushed to respond to each change in style and taste. Thus, waves of architectural styles swept over Cape May during the Victorian era. These included Gothic Revival (1850–75), Italianate (1860–85), Mansard or Second Empire (1865–95), Stick (1875–85), Queen Anne (1885–1910), Colonial Revival (1890–1915) and Shingle (1905–20), according to Mid-Atlantic Center for the Arts director Dr. B. Michael Zuckerman, whose background is in history and architecture. As the era ended, the American Craftsman Bungalow style was just beginning to rise to prominence.

Interestingly, it took each of these styles a decade or more from the time they first became popular in the nation until that style first began to appear

in Cape May. Some Victorians simply added touches of the latest style to their existing structures; thus, mixtures of styles, such as Mansard and Queen Anne or Gothic Revival and Mansard, were common.

Cape May also has several examples of unique and exotic Victorian architectural styles. These include Spanish Colonial Revival, Swiss Chalet, English Tudor Revival, a home modeled after a Venetian palace and an octagonal house. Most were either examples of self-expression by the owner and/or ways of reminding passersby that the owners were affluent enough to travel to foreign lands and cultured enough to appreciate exotic styles.

Victorian architectural styles in Cape May shared some characteristics. All were ornate by modern standards. All had porches, often multiple and/or wraparound. Many featured bay windows and ornamentation on the roof such as cresting (fence-like trim) or acroteria (crown-like trim). Most had varying degrees of intricate, lacy woodwork that we tend to call gingerbread trim. Most drew their inspiration to some degree from the architectural ideas of what a "country" house should look like, as expressed by the influential early Victorian architect Andrew Jackson Downing in his *The Architecture of Country Houses* (1850).

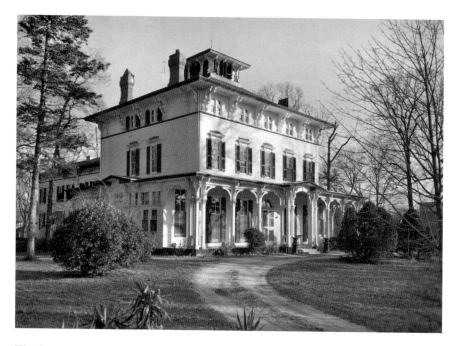

The George Allen House, designed by Samuel Sloan. *Courtesy of the Library of Congress.*

Several noted Victorian architects designed homes in Cape May. The Physick Estate is attributed to Frank Furness, who also had a summer cottage of his own on Grant Street. Samuel Sloan designed the George Allen House, which is now the Southern Mansion. The most prolific Victorian architect of note in Cape May was Stephen Decatur Button. Among his works are Jackson's Clubhouse/Mainstay Inn, the Stockton Row Cottages, the John McCreary House/Abbey and the Seven Sisters.

Gothic Revival Style

One of the earliest Victorian architectural styles in both the United States and Cape May was the Gothic Revival, which was popular in the nation from 1835 to 1875 and in Cape May from 1850 to 1875. This time lag in a style's popularity was typical. It often took a decade or more for the latest architectural style to reach Cape May. This style was inspired by English and European buildings of previous centuries.

Gothic Revival buildings have very steeply arched roofs, often with a crown-like ornament called an acroterion or a mini-steeple called a finial

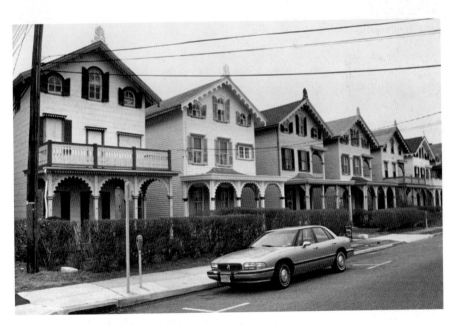

Stockton Row Cottages. *Courtesy of Mid-Atlantic Center.*

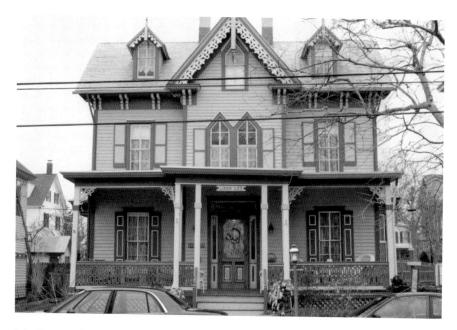

John Benezet Cottage/Linda Lee. *Courtesy of Mid-Atlantic Center.*

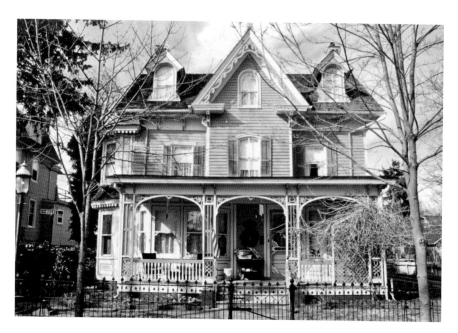

Joseph Hall Cottage. *Courtesy of Mid-Atlantic Center.*

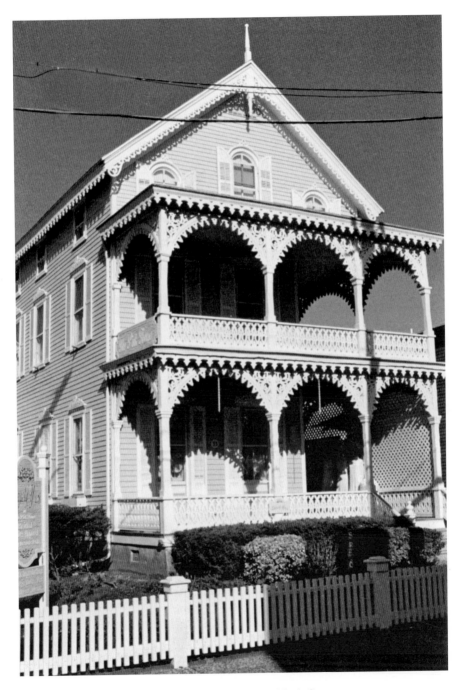

Eldredge Johnson House/Pink House. *Courtesy of Mid-Atlantic Center.*

at the peak. Often, finials extend below the roofline to become pendants. The steeply pitched gable of the roof is usually in its center. The tops of some of the windows of a Gothic Revival–style structure are also steeply pitched. The extensive use of ornate woodwork, sometimes called fretwork or carpenter's lace, is typical of the Gothic Revival style. Sometimes this leads to unofficial substyles called Steamboat Gothic or Carpenter Gothic, such as the Eldridge Johnson House/Pink House. This ornate woodwork is also commonly referred to as "gingerbread" and includes vergeboard under the eaves and spandrels between porch posts.

In addition to the aforementioned Pink House, some other examples of Gothic Revival styles in Cape May are the John McCreary House/Abbey, the Stratton Ware House, the Joseph Hall Cottage, the John Tack House/ Ashley Rose Victorian Inn and the Stockton Row Cottages. The John Benezet Cottage/Linda Lee, the Steiner Brothers Cottages, the former St. John's Episcopal Church/Episcopal Church of the Advent, the former Cape Island Baptist/Franklin St. Methodist Church and the Cape Island Presbyterian Church are also examples of this style of Victorian architecture.

Italianate Style

The Italianate style of Victorian architecture became popular in Cape May from 1860 to 1885. Its period of greatest popularity nationwide was 1840–80, which again causes us to note the time lag between when a style came in vogue in the nation and when that trend reached Cape May. It drew its inspiration from Italian country villas.

Some of Cape May's most famous buildings are of this style. These include the Chalfonte, Jackson's Clubhouse/Mainstay Inn, the George Allen House/Southern Mansion, the Jacob Neafie House, the Seven Sisters, the Bedford, the Caroll Villa, the Ebbit House/Virginia Hotel and Denizot's Ocean View House/Cabanas.

Italianate buildings are usually square or rectangular and very symmetrical. Many have cupolas or belvederes in the middle of their roofs. Brackets, sometimes large, sometimes paired and sometimes sandwiched, seem to support the roof. Any center gable is very low pitched. Often, the porch post edges are planed or chamfered. It's not unusual for some window tops to be rounded or curved.

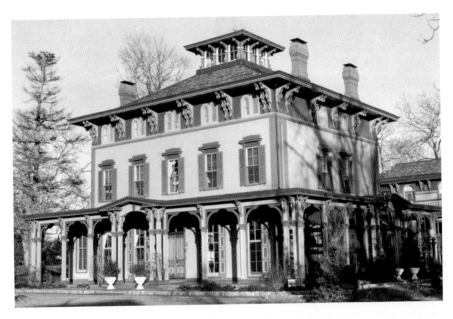

George Allen House/Southern Mansion. *Courtesy of Mid-Atlantic Center.*

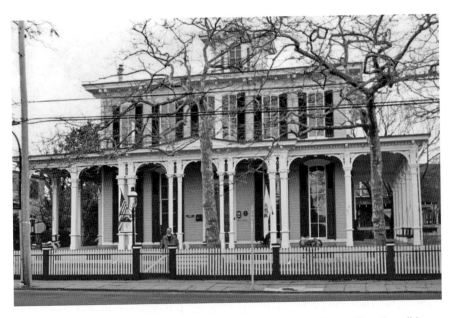

Jackson's Clubhouse/Mainstay Inn with Cape May preservation pioneer Tom Carroll in front. *Courtesy of Mid-Atlantic Center.*

Mansard Style

Named for its unique flat roof that covers its top floor, which was in turn named for its creator, this style was also called Second Empire after the second French empire of Louis Napoleon that favored such buildings. Contrary to popular myth, its popularity in the United States had nothing to do with an old French law taxing a structure according to the number of rooms below the roofline. There was no such taxing practice in Victorian America, thus no motivation to have a floor of rooms tucked under the roof. The status-conscious Victorians had every motivation to emulate the practices of French nobility, however. The Mansard style was popular in the United States from 1855 to 1880 and then in Cape May from 1865 to 1895.

Below its distinctive roof, a Mansard structure was almost identical to an Italianate one. There are three styles of Mansard roof: straight, concave (curving in) and convex (curving out). All are found in Cape May. The Douglas Gregory House/Queen Victoria is a concave Mansard. The John McCreary Cottage/Abbey Cottage is a convex Mansard. The Thomas Webster House is a straight Mansard. Mansards often feature patterned,

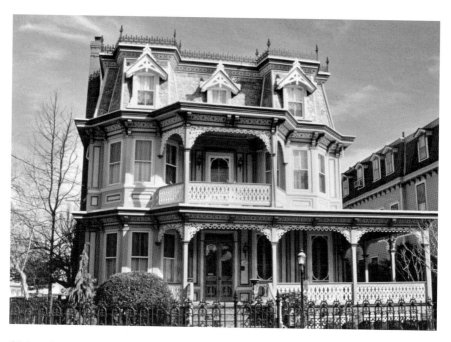

Christopher Gallagher House. *Courtesy of Mid-Atlantic Center.*

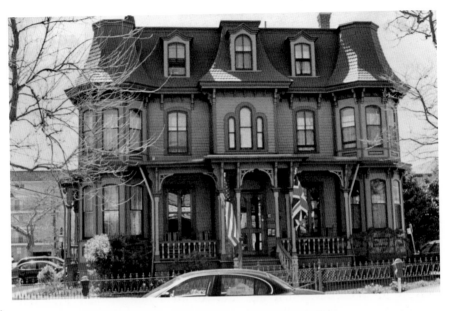

Douglas Gregory House/Queen Victoria. *Courtesy of Mid-Atlantic Center.*

multicolored slate roofs. Some of these in Cape May include the Christopher Gallagher House, the George Hildreth House/Poor Richard's Inn and the White Dove Cottage.

Interestingly, noted architect Frank Furness's summer cottage on Grant Street is also in the Mansard style.

Many Cape May Victorian hotels, such as Congress Hall and the now-gone Windsor, Lafayette and Stockton, featured Mansard roofs.

Stick Style

During the middle of the Victorian era, architecture and the decorative arts experienced a reaction to the ornateness of previous styles such as Gothic Revival, Italianate and Mansard exteriors and Rococo interiors. It was an effort to get back to a simpler, more functional, less decorative style. In home furnishings, the style was called Eastlake after one of the movement's leaders, Charles Eastlake. Its architectural equivalent was the Stick style. This style was popular in the nation from 1865 to 1990 and in Cape May from 1875 to 1885.

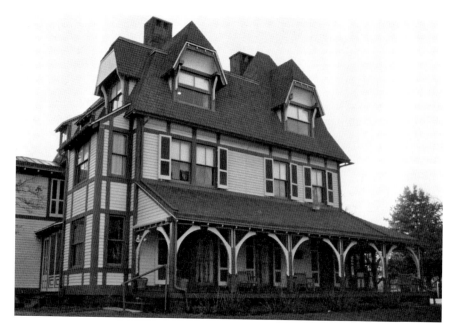

Emlen Physick Estate. *Courtesy of Mid-Atlantic Center.*

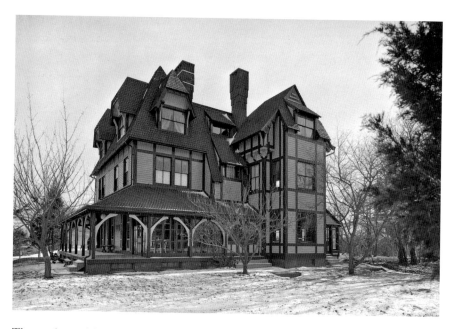

The northeast side and northwest front of the Emlen Physick Estate. *Courtesy of the Library of Congress.*

The Stick style tried to emphasize a structure's true form and construction, thus its characteristic horizontal and vertical grid work beams on outside walls, which, while ornamental, reminded one of the skeletal frame of the building. These beams were called stick work. The porch brackets were simple arcs, devoid of ornamentation. The projections coming from the building were all squarish or rectangular. Two types of dormers were used on Stick structures: the trapdoor-like pent and the Jerkin head. The latter gave the appearance of a hood over the window. Overall, the Stick style is unique among Victorian architectural styles because of its almost complete lack of gingerbread trim.

The Emlen Physick Estate is Cape May's prime example of Stick-style Victorian architecture. The Memucan Hughes I House on Hughes Street is also in this style. Elements of it mixed with other styles can also be seen on Fryer's Cottage/King's Cottage and the John McConnell House.

Queen Anne Style

Interestingly, and perhaps revealingly, the architectural style that followed the relatively simple Stick style in popularity was the most ornate of Victorian architectural styles: the Queen Anne style. Perhaps this reflected the basic Victorian preference for the ornate and elaborate as symbolic of their desire to display their new wealth and social status. The Queen Anne style was popular from 1875 to 1910 in the nation and 1885 to 1910 in Cape May. Named for an early eighteenth-century English monarch, it reflected what the Victorians imagined the tastes and styles of her reign were rather than the reality of same.

Queen Anne structures are asymmetrical and feature one or more towers or turrets of various shapes and with various types of roofs. The latter includes ones of polygonal, witch's cap or bell shape. A tower is distinguished from a turret by extending from above the main roofline to the ground, while a turret stops before the ground, usually at the eaves or uppermost floor. The main roof of a Queen Anne structure is often as steeply pitched as that of a Gothic Revival building. Another distinguishing feature of the Queen Anne style is the use of round, patterned porch posts that have been turned on a lathe and thus are called turned posts. Queen Annes also often have two styles of shingling. Shingles with rounded, scalloped ends like fish scales are called just that—fish scale shingles. Shingles that are pointed at the end like

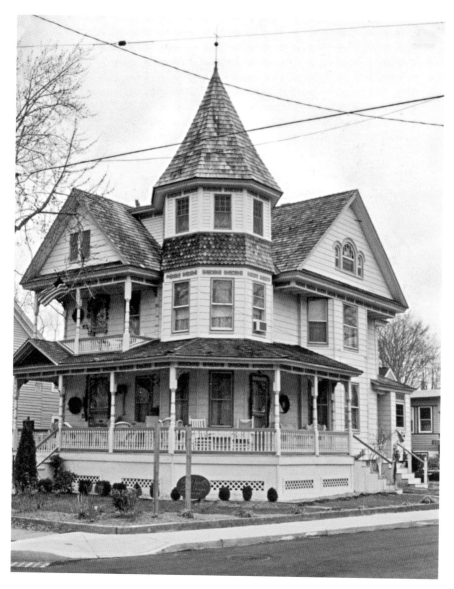

Judson Bennet House. *Courtesy of Mid-Atlantic Center.*

a shark's tooth are called shark's tooth shingles. The use of alternating rows, or courses, of each was popular on Queen Anne buildings. If the owner had other decorative favorites like three-part Palladian windows, rosettes or vergeboard, spandrels and other types of carpenter's lace, these could be abundantly added. Never was the Victorian feeling that

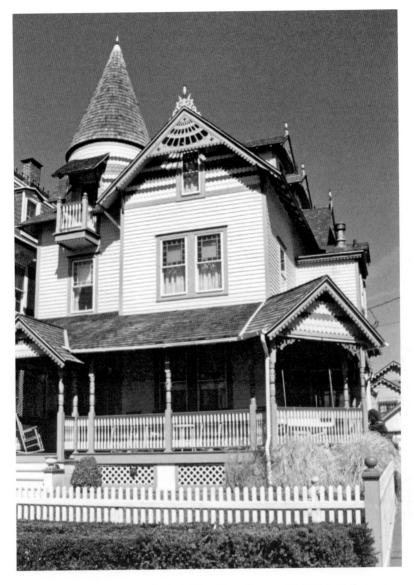

Beaver Cottage/Beauclaire's Bed and Breakfast. *Courtesy of Mid-Atlantic Center.*

"more is better and there is no such thing as too much" illustrated better than in Queen Anne architecture.

Cape May is full of Queen Anne–style buildings. The Judson Bennet House has a polygonal tower roof. The Leedom House has a witch's cap roof on its fish scale shingle-clad tower. The Duke of Windsor has a polygonal

roofed tower, while the Harry Parker Cottage/Inn at 22 Jackson Street has a polygonal roof on its turret. The Evan Morris Cottage/Seaview House has a bell domed roof on its turret. The Beaver Cottage/Beauclaire's has a witch's cap roofed turret. The tower of the James Hildreth House/Spilker Funeral Home is in the middle of the building.

Colonial Revival Style

One of the latest of the Victorian architectural styles is the Colonial Revival. This style grew out of renewed interest in, and appreciation of, colonial and Revolutionary America sparked by the 1876 Centennial Exposition in Philadelphia. It was popular in the nation from 1885 to 1910 and in Cape May from 1890 to 1915.

Cape May has several fine examples of this style. These include the Dr. Phillips House/Captain Mey's Inn, the Humphrey Hughes House, the Peter Shields House, the George Boyd House and the J.F. Jacoby House/Dormer House.

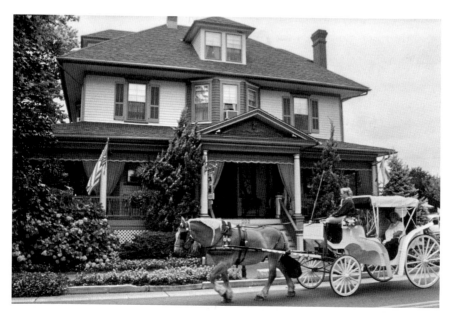

Dr. Phillips House/Captain Mey's Inn. *Courtesy of Mid-Atlantic Center.*

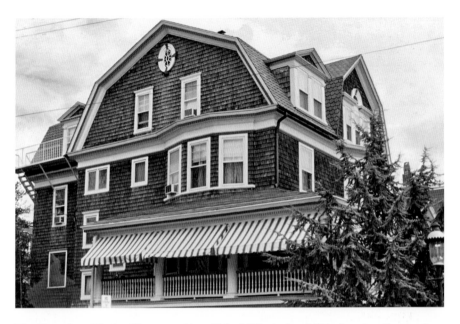

The Humphrey Hughes House combines Colonial Revival and Shingle styles. *Courtesy of Mid-Atlantic Center.*

The characteristics of a Colonial Revival–style building are round, smooth porch posts that are often clustered in pairs or trios, large roof dormers, a triangular pediment over the main entrance and a barn-like gambreled roofline. Often, wide sidelights and transoms/fanlights are featured around doors, especially the main entrance.

In Cape May, Colonial Revival homes were also often covered with cedar shingles.

Shingle Style

Another late Victorian architectural style was the Shingle style. It was popular in the United States from 1880 to 1910 and in Cape May from 1885 to 1920. Thus, it is another example of the Cape May architectural time lag noted previously.

The most obvious identifier of a Shingle-style building is its shingles. They are most often of cedar and cover the building. Beyond roofs and walls, some porch posts and balustrades were shingle covered. Beyond aesthetics,

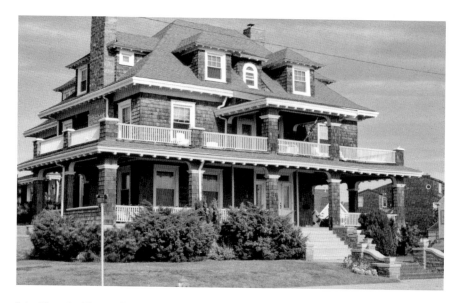

John Forsythe House. *Courtesy of Mid-Atlantic Center.*

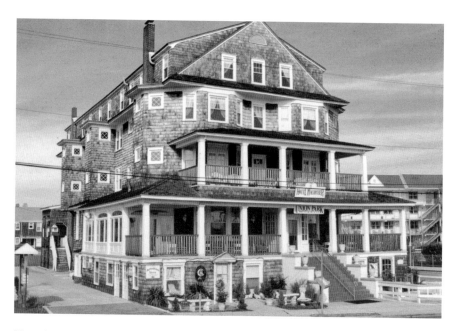

Newe Stockton Villa/Hotel Macomber. *Courtesy of Mid-Atlantic Center.*

shingles were much more weather resistant than painted surfaces. This had special appeal to owners of summer cottages buffeted by salt air winds and sea spray and drenched by daily sunshine.

In Cape May, many Colonial Revival structures are also Shingle style. Examples of Shingle style in Cape May include the Humphrey Hughes House, the Hotel Macomber, the John Forsythe House, the William Sewell House and the Frederick Harding Cottage.

Exotic Style

One highly visual tactic Victorians employed to remind those around them that they had the wealth to travel worldwide and/or sophisticated cosmopolitan tastes was to employ an exotic style of architecture, usually from some distant culture, in constructing their home. The same world awareness could be projected in public buildings, which only the truly sophisticated could recognize and enjoy. This trend toward exotic

The Cape Island Baptist Church, in the Spanish Colonial Revival Exotic style. *Courtesy of the Library of Congress.*

The Swiss Chalet Exotic-style Rhythm of the Sea. *Courtesy of Mid-Atlantic Center.*

A Tudor Revival Exotic-style private home on New Jersey Avenue. *Courtesy of Mid-Atlantic Center.*

Exotic-style octagonal Josiah Schellinger House. *Courtesy of Mid-Atlantic Center.*

architectural styles became especially popular after the Philadelphia Centennial Exposition of 1876 and Chicago World's Fair/Columbian Exposition of 1893.

Cape May has a fascinating collage of these exotic styles. The Cape Island Baptist Church and Nelson Graves House/Mission Inn are in the Spanish Colonial Revival style. Two homes in the 1000 block of New Jersey Avenue are Tudor Revival, reminiscent of "merry olde England," as is the Dr. Walter Starr Cottage. The New Jersey Trust and Safe Deposit Company/ Winterwood Gift Shop is in the Renaissance Revival style. Columns by the Sea on Beach Drive reminds one of an Italian Renaissance palace (sans shingles), while a few blocks away the Rhythm of the Sea is strongly reminiscent of a Swiss chalet. The Victorian Visitor's Church/Cape May Stage has a Moorish bell tower with a Russian onion domed roof. There is even an octagonal house in Cape May, the Josiah Schellinger House on Lafayette Street, which is an example of exotic mid-nineteenth-century American architecture but was built in 1875.

Eclectic Style

Given the Victorians' obsession with exhibiting the cosmopolitan sophistication and good taste and their decorative credo that more is better and there is no such thing as too much, it is easy to understand why many of their homes and other structures ended up being mixtures of many architectural styles. Often, additions or modifications reflective of the latest style were added to existing buildings or several of the owner's favorite styles were combined in a new building. Some Victorian styles were virtually mixed styles in themselves. The Mansard style included many Italianate features. The Queen Anne style allowed for the inclusion of features from most previous styles, as well as almost any embellishment the owner favored.

Cape May is full of such eclectically styled structures. The Colonial Hotel/Inn of Cape May combines a Mansard roof with an Italianate cupola and Queen Anne towers. The Weightman Cottage/Angel of the Sea combines a Mansard with Queen Anne and Gothic Revival features. The J. Henry Edmonds House/Merry Widow combines a Mansard roofline with one of the town's most ornate Queen Anne towers.

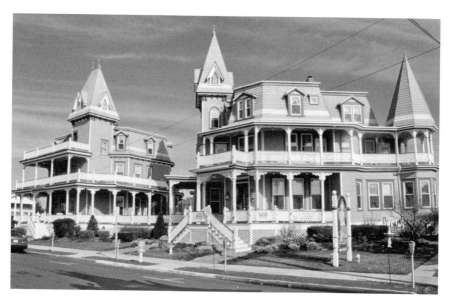

The eclectic William Weightman Cottage/Angel of the Sea combines Queen Anne, Mansard and Gothic Revival styles. *Courtesy of Mid-Atlantic Center.*

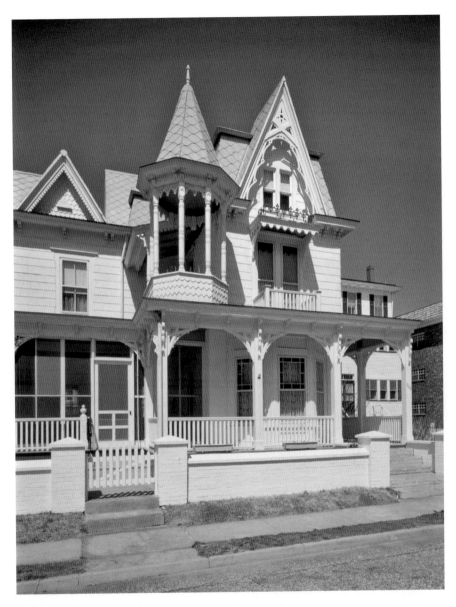

Dr. Henry F. Hunt Cottage. *Courtesy of the Library of Congress.*

Cape May's most eclectic building is the Dr. Henry Hunt Cottage, which is a mixture of five Victorian architectural styles: Gothic Revival, Italianate, Mansard, Stick and Queen Anne. Aficionados of Victorian architecture can use it as a final exam on the topic.

Passing Admission Tests in Entrance Hall

As visitors approach a Victorian's home, they should be aware that they are seeking admission to not just a physical structure but a socioeconomic one as well. To gain admission will be either a confirmation or reconfirmation that one is of a status at least equal to, if not higher than, your host. Actually, it would be more accurate to say your hostesses as women were the arbiters of social acceptance in the Victorian era. A man's income or power might make his family a candidate for upward social mobility and/or social acceptance, but more often than not, ladies stamped his family's social passport.

Victorian women spent many midday hours in the social ritual of "calling" or visiting one another's homes. The calling ritual either reinforced their family's social status or improved it. In the dynamic Victorian business world, fortunes and, thus, status could be gained or lost virtually overnight. In the dynamic Victorian social world, the same could happen to reputations and status. An accepted call reconfirmed one's status and resoldered one's social connections. To the upwardly mobile—and almost everyone was—calling could also rewire them into an even higher social level.

The entrance halls of Victorian homes were the sites of these social class admission tests. A servant met you at the door and ushered you into this outer room. You presented your calling cards to the servant, who took them to the lady of the house. These cards were much like modern business cards, and you usually presented multiple copies. While you awaited an admission decision, you sat on straight-backed chairs and reviewed your physical appearance in front of the hallstand mirror. You were surrounded by a series of closed doors leading to adjoining rooms and a grand staircase descending from the upper floors. Nervous? Good, you're supposed to be! If your call was accepted, the servant announced the family or lady was "at home" and now welcomed you, taking your coat, hat and parasol or cane and putting them in the appropriate locations about the hallstand. You now had a few seconds to primp again before your host(s) descended the staircase to greet you. It had taken a few minutes for them to use a rear stairway to the second floor to primp themselves before descending to properly impress you with their substance, elegance, decorum and respectability. Your physical appearance, rechecked in front of the hallstand, returned this message in kind. Note that they descended from above you, signifying that while you are accepted as an equal, they are just a bit "more equal" as your host(s).

If your call was not accepted, if the family was not at home for you, you quietly left with decorum. Perhaps next week, when you would call again,

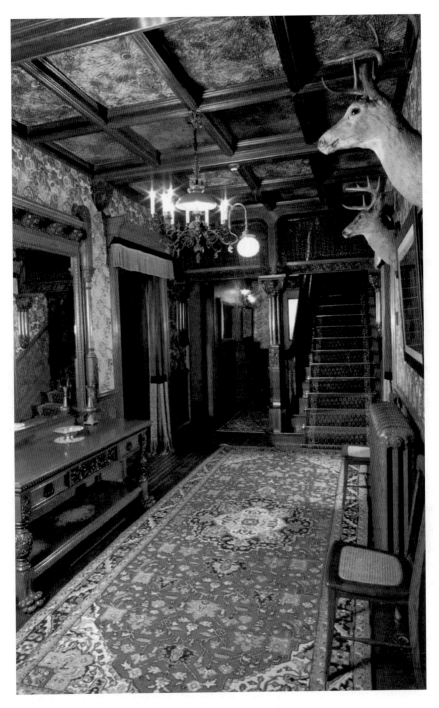

Entrance hall of the Physick Estate. *Courtesy of Mid-Atlantic Center.*

they would be at home for you. You would have a week to remedy your socioeconomic faults.

The same process occurred if you were a previously invited guest, perhaps for a tea or dinner party. Again, a servant received your cards but this time simultaneously took your hats, coats, etc. while welcoming you and then ushering you into the formal parlor to join the family and their other guests. In this scenario, your name on the list of invited guests was your passport and reconfirmation of your status.

Next we'll join the mutual admiration and confirmation society meeting in the formal parlor.

Tea and Respectability in the Formal Parlor

Now that we have passed the admissions test screening process in the entrance hall, as guests in a Victorian house we would enter the formal parlor. Just as all other rooms, and the house itself, it had a "secret life" (to paraphrase the concept elaborated in Elan and Susan Zingman-Leith's insightful book of that title) and revealed insights into the Victorians' lifestyle.

Formal parlors were reserved for entertaining, and the family spent little time there except for social events. They were usually the most elaborately decorated room in the house. Here, as in no other room, the Victorian family that had it flaunted it. Highlights might include matching parlor sofas and chairs (a new concept), an expansive fireplace and numerous display stands, tables and shelves. Here the family displayed the latest décor items, indicating their sophistication. Displayed with a similar purpose were works of art currently in vogue. Also displayed were family photos and artifacts illustrating the accomplishments and status of the family. Seating was deliberately upright in this room also, emphasizing the formality of events taking place here such as polite conversation over tea while simultaneously engaging in mutual group preening. Underwriting all of this was the not so subtly stated wealth of the family.

Here in the formal parlor, the lady of the house displayed her domestic skills in decorating and entertaining. Here she displayed how simultaneously domestic and sophisticated she and her family were. Here she also displayed items as conversation pieces. These pieces were intended to promote not idle conversation but conversation about the family's accomplishments or illustrative of its substance, respectability and status.

Formal parlor of the Physick Estate. *Courtesy of Mid-Atlantic Center.*

Formal parlors were most often used as sites for afternoon teas among the lady's equally substantive and respectable female friends, for pre-dinner gatherings or for parties honoring an especially prestigious guest. Funerals

were also held here, necessitating special access via combination window/ doors for the casket. Ironically, these same apertures could be used to access the porches that often wrapped around the formal parlor, which greatly expanded entertaining space in pleasant weather. When funeral sites shifted to business establishments, these buildings were called funeral parlors to ease this cultural transition.

Often adjacent to the formal parlor was the music room, another public (not private or family) room used in entertaining guests. In the next section, we'll continue our guided tour of a Victorian home and the secrets about the Victorian lifestyle revealed therein. Again, a reminder to ensure your ongoing acceptance by continuing to act tremendously impressed with the house and your hosts as you move from room to room.

Appreciating Music and Status in the Music Room

A prime outward indication of one's being a person or family of substance, sophistication and respectability was the ability to appreciate fine music. Thus, no Victorian house of the upper classes would be without a music room. Usually this was adjacent to the formal parlor and also just off the entrance hall, as it was primarily a public room for entertaining guests. However, Victorians truly loved music beyond its status value, so the family might spend time in this room even when alone.

The two essentials for a music room were a variety of instruments and seating to listen to or even participate in instrumental recitals and vocalizing. The parlor organ, and later the piano, was the essential Victorian status symbol. It was the first thing the newly rich, or those pretending or aspiring to be, purchased as proof of their new status. The room's décor, busts of famous composers and pictures of notable performers were scattered about in the usual Victorian profusion. Since this was an age of musical giants from Brahms, Liszt, Tchaikovsky, Wagner, Verdi and Elgar through Gilbert and Sullivan to Sousa, there were plenty of images to choose from.

The ability to play an instrument, primarily an organ or piano but also strings, was part of the refinement of Victorian women. Men might be found at the keyboard during private family moments but usually limited themselves to group singing in public unless they were professional musicians. Music was the Victorians' prime home entertainment. Upper-class Victorian

Music room of the Physick Estate. *Courtesy of Mid-Atlantic Center.*

homes resonated with the waltzes of the Strausses, the symphonies of Mendelssohn, the operas of Rossini and the concertos of Chopin. In less affluent neighborhoods, the new music of Scott Joplin and the harmonizing of barbershop singers might be heard. Throughout the community, Sousa marches and church hymns echoed.

Beyond actual music, Victorian music rooms might also be the site of other entertainments such as charades or the costumed reenactment of scenes from history and literature, or even the so-called parlor games if that room was already devoted to other entertaining.

As they participated in all these activities—musical, literary, theatrical and recreational—upper-class Victorians were reinforcing and emphasizing their elite status, their gentility, their substance and their respectability. Above all, they were confirming that they had the leisure time and affluence to appreciate these finer things in life, being people of "the better sort."

Nourishing One's Status and Self in the Dining Room

Victorians did not eat meals so much as they dined. How they ate was of at least equal importance to what they ate. Victorian meals, especially the main one in the evening, were extravagances of elegance and etiquette.

A full Victorian dinner consisted of a dozen or more courses served over two or three hours. Each separate course had its own distinct china, stemware and silverware, which was removed when the course was concluded. Each course was served by multiple servants who rushed the food from the nearby kitchen to the sideboard and then to each diner. The Victorians developed the elaborate sideboard, often the most expensive piece of furniture in the dining room, to facilitate this type of meal service. This practice of having separate courses served by servers was known as service a la Russe and came from the court of the Russian czars.

This style of dining offered upper-class Victorians ample opportunities to display their affluence, sophistication, cosmopolitan nature and general good breeding. Only the wealthy leisure class had the time and resources to eat this way or, more precisely, dine in this manner. What a fine, socially

Dining room of the Physick Estate. *Courtesy of Mid-Atlantic Center.*

acceptable way to show off how much china, stemware and silverware one possessed and how many servants one could employ.

The food itself was the finest available, of course, including items shipped in via the new refrigerated railroad cars or from the new food cans. At each place, a menu detailed the night's courses and offerings lest the unobservant be unappreciative. An appropriate wine, tea or other beverage accompanied each course.

Diners had to be careful not to devote too much attention to eating lest they make an error of etiquette. Such errors could include improper posture and chair positioning; using an incorrect plate, glass or implement; forgetting to use the finger bowl, thus soiling one's napkin; failure to signal one's eating status to the servants via silverware placement; eating too much or too little; talking with food in one's mouth; and failure to participate in properly polite conversation. Only by partaking of the smallest bits of food could the guest guard against the latter trio of indiscretions. Moderns attending parties with lots of food and lots of conversation but tiny plates can identify with the Victorian dinner guest's dilemma.

In the dining room, as throughout the Victorian house, both hosts and guests alike were constantly measuring themselves against the standards expected of people of "the better sort," people of substance and respectability, people of affluence and status. In their dining rooms, as in most of the rooms of their houses and in their houses themselves, Victorians signaled and sought recognition of their socioeconomic status. As in their interior décor, there was no such thing as too much status and recognition of same. Rituals such as dining offered Victorians ample opportunity to mutually nourish each other's socio-psychological needs. Toward this goal, are you being a proper Victorian guest and giving frequent indicators of how impressed you are with your hosts and their home?

The Sitting Room—The Family's Sanctuary

As we resume our tour of a typical Victorian house, we are privileged to enter parts of the house not normally accessible to the general public. We are obviously close family friends, as we will be allowed to visit and enjoy the Victorian sitting room, library, study, children's room(s) and even discreetly discuss the indoor bathroom(s) and the bedrooms. First we enter the room the family spent the most time in: the sitting room or family parlor.

Sitting room/family parlor of the Physick Estate. *Courtesy of the Library of Congress.*

The sitting room was a sanctuary within a sanctuary. It was the innermost asylum within the Victorian family's castle, providing the ultimate safe haven from the stress of the social Darwinist competition in both economic and social life. Here the family could be as informal and relaxed as they ever became, although it might be difficult to the modern eye to notice this. This was the altar of the Victorian cult of domesticity. The chairs were more comfortable. There might have been a piano, parlor organ and/or Victrola to provide the music the Victorians so loved. There might have been board and parlor games available and probably a mini-library. On one table we would find the family Bible containing its genealogy and on another a cherished photo album. The room was decorated with items that the family really liked and were really meaningful to them, as contrasted to items that were currently chic or status symbols. Do you know if the Christmas tree was here or in the formal parlor? This might indicate the family's priorities between public display and personal enjoyment of this cherished Christmas symbol. The same might be learned from the location of family photos: whose image is where and why? Notice the interior décor style. Was it different from

the public rooms? If so, perhaps you've learned the family's true tastes as contrasted to what is currently the rage. This and other contrasts between the public rooms and this semi-public room can provide volumes of insight into the family's concern with their public image, which in turn allows you to read, understand and appreciate their sense of security and status.

But wait—didn't the family establish this room to escape the ongoing analysis and evaluation of others in the world beyond this room? Perhaps we've become a bit too intrusive. Let's move on to other semi-private rooms, starting with the library. We'll have to keep reminding ourselves that we are privileged guests in this part of our hosts' home and to not abuse that privilege to satisfy our intellectual curiosity.

Educating Oneself and One's Guests in the Library

As we enter the library, we are reminded of the important role education played in Victorian culture. Education was seen as both a means toward and a symbol of the upper-class lifestyle. One both used and flaunted one's education. It was an age of constant upward striving and of a faith that science and its resultant technology would help man eventually tame nature and solve all problems, and education was held to be the key to both. Education also was an indicator that one had the time and intellect to successfully pursue knowledge. Clearly, it marked one as at the apex of the evolutionary chain. In addition, the spirit of noblesse oblige compelled the upper classes to assume patrician leadership of their society. To do so, upper-class Victorians were driven to be figurative renaissance men, with apparent interest and expertise in myriad subjects. This had been a tradition in the United States since colonial days.

In the library, Victorians engaged in what we would call today lifelong learning. Avid readers of books, newspapers and the newly emerging magazines, they spent hours reading for both self-improvement and pleasure.

For most of the era, the library was a separate room featuring not only the expected bookcases and comfortable chairs but also stands for portfolios and oversized books, a map case, a book table and a desk. It also had a decidedly male atmosphere and was dominated by men.

If the library had been solely devoted to self-improvement, it would have been strictly a private room, but its other purpose compelled it to be at least semi-public. It was by displaying to guests one's library and its contents

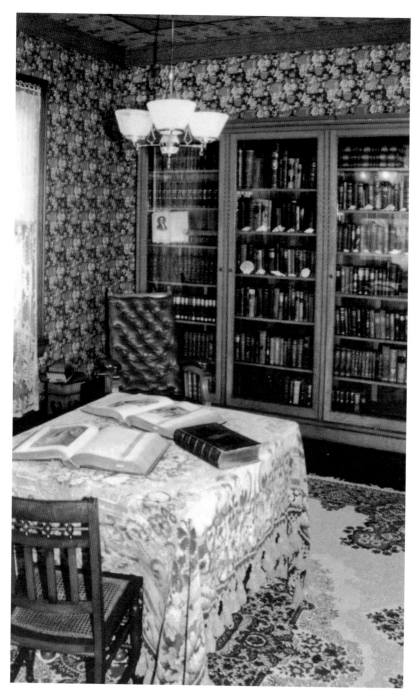

Library of the Physick Estate. *Courtesy of Mid-Atlantic Center.*

that one again educated them as to the family's substance, sophistication and status. The library indicated the family's intellectual and cosmopolitan superiority, their ability to appreciate the cultured life and their having the money, time and taste to do so.

The dual purpose of the library created one of several dilemmas as to its status and placement. Should it be public and readily accessible for guests or private in a secluded part of the home? Shall it be a male entertaining room, a place for gentlemen to adjourn to for brandy or port and cigars after dinner, or shall it be father's retreat and inner sanctum? Many Victorians solved this dilemma by establishing a separate library-like study or den for papa, making the library a semi-public room. Another option was to add bookcases, bookstands and book tables to the parlor. Adding another room or making an existing one even more cluttered was certainly in the spirit of Victorian home décor.

As the Victorian era progressed, two other dilemmas regarding education and thus the status of libraries emerged. These involved women and the working class. In an increasingly industrialized and technological economy, a better-educated worker was needed. As education spread, it was in danger of losing its elitist status. Public schools were producing workers who read newspapers and had bookcases in their parlors. A partial solution to this dilemma was to create higher education in contrast to public education. As the masses flocked to Chautauquas, people of "the better sort" displayed diplomas from "the right universities" in their libraries for guests to notice and appreciate. They also expanded their private library collections to rival the newly created public ones.

As the number of educated women grew, the male dominance of the library diminished. The aroma of cigars and spirits dissipated, and the library became much more of a family room in many later Victorian houses. Moving books to the parlor or sitting room and men to the den or study were alternative solutions.

There was much to be learned in a Victorian library. Our visit to the library has been perhaps even more educational than our hosts intended!

Learning About Children by Visiting Their Rooms

Victorian views of children changed significantly as the era progressed, and therefore, so did children's rooms. The style and furnishings of children's

rooms can help the visitor identify which years within the Victorian era they and the house are in.

Early in the era, most Victorians retained the view of children they had inherited from the colonial and federalist periods. Frankly, children were inadequate, irrational creatures so vulnerable to accident, disease and death that it was unwise to invest too much emotion and too many resources in them. Worse, they tended to be a drain on the family's energy and resources. The sooner they became at least mini-adults, the better. This development toward being responsible, contributing family members was forced as soon as possible. Children were basically unisex in dress and grooming until age seven. They had no separate rooms and no distinct furniture, being kept with adults full time, the better and quicker to model themselves after adults.

By the late 1840s, Victorians adopted a more romanticized view of children, consistent with their idealized view of the family. Children were now androgynous angels descended from heaven. These pure creatures were to be protected as long as possible from the contamination of earthly life. Still unisex in grooming and attire, these innocent and, therefore, certainly sexless cherubs were to be protected by sequestering them for their own good. Typically their rooms, usually a nursery and/or bedroom and a playroom, were in the most isolated and private place in the house. This was usually on the uppermost floor in the rear or atop a garret or tower or turret. They slept, played and ate there under the care of a nurse in upper-class homes. The décor and furnishings were minimalist and secondhand adult items. The few specialized furniture pieces were all designed to protect them from the dangers of the world by restricting their movement within it: a crib, a highchair and a jumper. The latter was a seat or harness tethered by springs to limit the child's mobility. The Victorian house was a dense jungle profuse with objects dangerous to children. Not coincidentally, restricting children's access to the rest of the house also protected its cluttered ornate opulence from breakage by children. Children were taught to strictly obey all adult commands, which were aimed at training them to eventually survive and prosper in the hostile adult and outside world.

By the 1880s, Victorian views of children and childhood had changed, and so had children's rooms. Protective training and sequestering gave way to guided introduction and orientation to the adult and outside world. Physical and intellectual exploration was now encouraged. Disobedience was not viewed as disgraceful but natural and was to be indulged and channeled into more acceptable behavior positively lest the child's latent natural talents and character be stifled. Parents encouraged independence and self-assertiveness.

To grandparents from the early part of the era, the sweet kitten or darling lamb had become the little emperor or little tyrant. While still headquartered in remote rooms, children now literally had the run of the house. It was their mother's duty to "child-proof" all rooms. Playpens and go-carts replaced jumpers, and children ate at miniature tables, not in highchairs. Age-specific furniture of all sorts now filled children's rooms. Toys, books and globes were now included also to encourage fantasy play and learning. Both furnishings and clothes now became gender-specific much earlier, with a military theme for boys and a maternal theme for girls. Separate bedrooms for male and female children became fashionable. Outdoor play was encouraged, and symbolically, windows or skylights appeared in garrets and towers to let light and air in. Children's clothing reflected this emphasis on activeness with rompers, dungarees, sunsuits and shorts appearing. By the end of the Victorian era, rooms for children had truly become children's rooms.

As with our visit to other rooms in a Victorian house and to the house as a whole, we continue to learn as much about the lifestyle and views of the Victorians as we do about their architecture and interior décor.

The New Room That Everybody Notices but No One Discusses: The Bathroom

We move now to the very private rooms: first the bathrooms and then the bedrooms. We will try to avoid offending delicate sensibilities in expressing our appreciation of these extremely personal areas and topics.

The indoor bathroom presents a dilemma to our hosts, and we need to be sensitive to it. A room devoted to bodily functions should not be discussed in polite society. Yet in the late Victorian home, it contains some of the most advanced technology in the home and offers testimony to our hosts' economic and social status. I suggest we duly notice the room and its contents and then avert our eyes and limit any comments to oblique ones focusing on how impressed we are that the home contains such ultra modern rooms with the latest fixtures, systems and technology and how only a family of substance, status and sophistication could have such marvels in their home.

The bathroom, as we know it, was definitely limited to the upper classes until after the Victorian era. Bathrooms were formed by the coalescing of various facilities from other parts of the house and grounds. This was made possible by culture-altering advances in technology such as gas- or oil-fueled

An add-on bathroom of a private home on Hughes Street. *Courtesy of Mid-Atlantic Center.*

water, waste, heating and lighting systems driven by ever more powerful engines and pumps. These utility systems were almost exclusively privately owned and only available to public buildings or the homes of the rich. From the outdoor "necessary" (if one was rich) or "outhouse" (of poor folk) or from bedroom chamber pots came toilets. From the same bedrooms came sinks. From the kitchen came tubs, now enlarged for bathing. Many of these fixtures were not only united in the bathroom but also made of the new sanitary ceramics. Separate rooms for men and women were common, with the men's room often containing a shower within a bathtub. Notice how more discreet the name bathroom is as compared to naming the room for some other bodily functions performed therein. In the future, men's rooms, ladies' rooms and restrooms would evolve as ongoing evidence that moderns have not completely severed their Victorian roots.

From the late 1870s on, more and more bathrooms appeared until by the turn of the century, "people of the better sort" wouldn't think of living in a home without them. They were built into new construction and added onto existing houses. Many of the latter appeared as extensions to second-floor bedrooms.

We've already probably devoted too much time and attention to this delicate subject. Let's quickly move on to another room. But don't forget

Add-on bathrooms of a private home and the Baltimore Hotel/Girls Friendly Society on Hughes Street. *Courtesy of Mid-Atlantic Center.*

to eventually discreetly compliment your hosts on the very existence and up-to-date technology of the bathrooms. Your hosts' discreet smiles will indicate that they understand how this has further impressed you as to their substance, status and sophistication.

Dr. Physick's bathroom at the Physick Estate. *Courtesy of Mid-Atlantic Center.*

A Discreet Discussion of Bedrooms

In our tour of a Victorian house, both our hosts and we guests have discreetly left the bedrooms for last by mutual understanding. As if the bathrooms were not intimately sensitive enough areas, now we arrive at the bedrooms. If sleeping were all that occurred therein, such discretion would be unnecessary, but the children's rooms we recently visited offer evidence that other activities of a highly private nature transpire here. Perhaps we should send the ladies

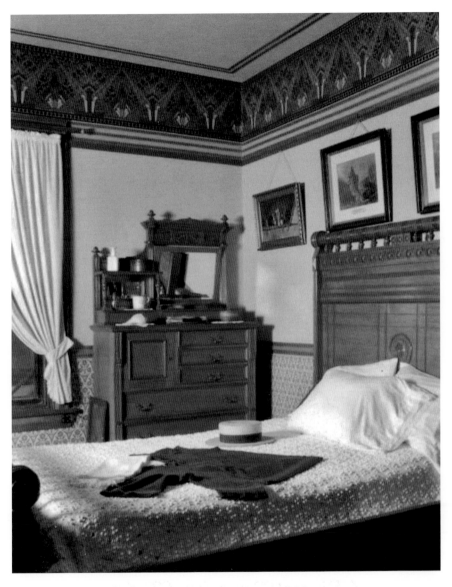

Dr. Physick's bedroom at the Physick Estate. *Courtesy of Mid-Atlantic Center.*

ahead, back to the formal parlor, lest they be overcome by the vapors at the contemplation of such matters in mixed company and have to avail themselves of the fainting couch in our hostess's bedroom. However, let's use the technique we used with the bathrooms, glancing quickly inside to scan décor highlights and then just as quickly averting our eyes. While descending

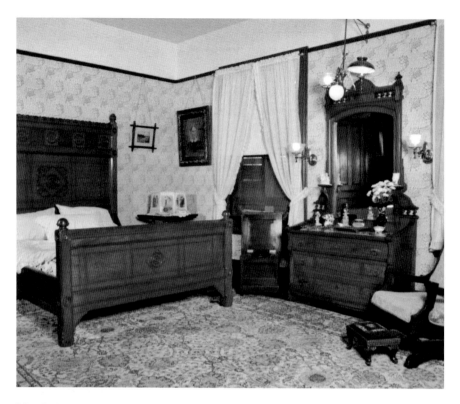

Mrs. Ralston's bedroom at the Physick Estate. *Courtesy of Mid-Atlantic Center.*

the formal front staircase to the entrance hall and parlor, we can obliquely express our appreciation of these rooms and of our host's respectability and status and the overall magnificence of their home, magnificence reflective of a family of "the better sort."

As with all rooms not viewed by the average guest, the bedrooms were not nearly as lavish and ornate as the entertaining rooms. The family had no noblesse oblige to model the lifestyle and taste of upper-class life here. The mere knowledge that their home contained multiple, individualized bedrooms testified to their status. The bedrooms were indeed both private and individualized. The husband's and wife's adjoined, with their current degree of harmony and compatibility signaled by whether the door was open or shut. The doors to the hallway of all bedrooms were always shut. Each room was decorated to reflect its occupant's true preferences rather than to impress outsiders with what was currently in vogue. The furniture would include chests of drawers, bureaus, nightstands and, of course, a bed. There

was no chamber pot, as it had been incorporated into a nearby bathroom. Beyond the décor, the presence of a dresser and sofa or fainting couch would indicate this was a woman's room. If you notice an easy chair and bookcase, it was probably a man's room. As the era progressed, bookcases and desks became more common in the bedrooms of both sexes. Sorry, I hope the use of the "s" word in conjunction with these rooms isn't offensive. Do you require some Laudanum, madame? Instead, let's just say bookcases and desks became less gender specific. Also as the era progressed, more and more convertible furniture appeared in bedrooms such as beds that converted to sofas or contained drawers or bookcases that hid mini-desks.

Let us leave the area of the bedrooms and bathrooms and return to the parlor via the grand front staircase and entrance hall. Use of this staircase was a privilege reserved for adult family members and their special adult guests and we are honored to descend it. Servants, tradesmen and children were restricted to the much plainer back stairs.

We've been privileged guests in an upper- or middle-class Victorian home. By granting us entrance into their home, the family has signaled to us their acceptance of us as people of the better sort like them, people of substance and respectability. We have been further honored by access to rooms not normally open to the public. The wife/mother goddess of the cult of domesticity has allowed us to study the innermost sanctuaries of her shrine. We can only thank her by praising her skill as a hostess and homemaker; her taste in interior décor; her skill in etiquette, decorum and manners; and her talents as a wife and mother. We should also acknowledge the skill and success in the business world of our host, which has allowed him to provide so ably for his family while simultaneously providing the proper benevolent paternalistic leadership for it. Most importantly, let's remember to again express how tremendously impressed we are with the house and everything in it, including the family. All this will undoubtedly ensure our return, unless a sudden reversal of our economic or social status should cause us to become people of the lesser sort again. If so, this would undoubtedly be due to some fault of ours, which we must correct while earnestly striving upward again toward readmittance to our hosts' socioeconomic class and home.

Physick Phantoms Marvel at Multiple Pleasures of Cape May

The invitation arrived via T-Mail (telepathy) every year as Halloween neared. The Physick family bid me to join them at their estate for our annual evening of spirited conversation. They were all there: Dr. Emlen; his mother, Mrs. Francis Palmentier Physick Ralston; and her sisters Emilie and Isabelle Palmentier. Poor, disturbed (both mentally and physically) Bell only manifests herself at Halloween.

This year, the Physicks were in an especially excited and energetic mood. Thus, their apparitions were quite clear. Their enthusiastic energy was all the more impressive since they are all over 150 years old. The reason for their enhanced appearance was the modern status of their spirited city, Cape May.

"We increasingly marvel at the multiple pleasures modern Cape May has to offer," summarized Dr. Physick. "For locals and visitors alike there is so much to do all year round. It's not like our day when the area seemed to go dormant between summer resorting seasons."

"So many resorters, or as moderns call them vacationers, doing so many things," enthused Mrs. Ralston. "There are tours, festivals and fairs, special speakers and show houses, concerts, races, the theaters, art shows, craft shows and auto shows," Emilie added. "I especially like the dragon boat races and clamshell pitching contest," Isabelle interjected, although she was difficult to apprehend as always. "Yes, we're considering entering each as a family next year," added Dr. Physick. "So many tours and festivals," Emilie continued. "Spring Festival, Seafood Festival, Harbor Festival, Strawberry Festival,

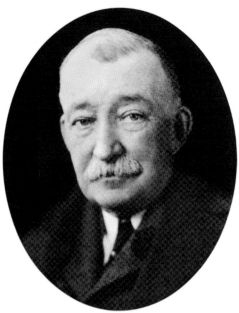

Birding Festivals, Singers and Songwriters Festival, Film Festival, Music Festival, Jazz Festivals, Sea Glass Festival, Wine Festivals and Oktoberfest, and so many tours, of town, on buses, bicycles and afoot, of the World War II tower, the lighthouse and our house and others." "I especially like the Craft Beer and Crab Festival and Lima Bean Festival and the ghost tours," Isabelle again eerily interjected. "Yes, and many are here on our estate," emphasized Dr. Physick. "My favorite is Victorian Weekend," added Mrs. Ralston. "So many proper people, properly dressed and doing proper things."

I added that there was so much and such a variety of things to do in Cape May starting with the historic sites and Victorian architecture but beyond that to the beach, birding, enjoying fine food and wines and beers, fishing and ambling through a variety of beautiful environments like the wetlands, fields and wooded areas. "Fishing," Dr. Physick

Top: Aunt Emilie with young Dr. Physick. *Courtesy of Mid-Atlantic Center.*

Left: Dr. Emlen Physick. *Courtesy of Mid-Atlantic Center.*

proclaimed, "why, Cape May is a leading commercial and recreational fishing port." I see so many ships as I sail about in the *Lorona* (his yacht). "There's the richest boat for boat marlin and tuna tournament, the *Mid-Atlantic*, and I've heard we're the third leading commercial fishing port in the United States thanks to our scalloping." "Do not forget the other fishing tournaments, Emlen," Mrs. Ralston added. "There are ones for sharks and striped bass and so many more." "Yes, mother," Dr. Physick responded quickly. "Birding," Emilie added, "we host the World Series of Birding each year." "I especially like eating and drinking," Isabelle again interjected. "There are six wineries and two breweries in the area, and we're the restaurant capital of New Jersey."

"There's so much to do. Emilie, Isabelle and I love the movies on the beach and roller skating at Convention Hall and a fascinating new program called TEDx," enthused Mrs. Ralston. "Is it proper for ladies to be there unescorted?" questioned Dr. Physick. "Oh yes," his mother replied, "and Emilie and I also like to shop in Cape May's unique variety of business establishments."

Brimming with pride, Dr. Physick proudly proclaimed other honors Cape May has won, including Top Ten Beaches, Top Ten Fall and Spring Trips to Take and Top Ten Prettiest Painted Places. "I like the name we've earned over the years: the Queen of the Seaside Resorts," Mrs. Ralston said smugly. "I especially like our being named one of the 101 places to visit before you die," interjected Isabelle with a strange smile.

"Halloween is here and Christmas is coming," said Mrs. Ralston gaily. "Everybody who is anybody comes to Cape May at Halloween and Christmas." "Yes, yes," Emilie added, "and so many have their weddings here too. Don't you wish you were ever married, Emlen? I know I do." "Harrumph!" was the good doctor's reply. He quickly added that the hour was getting late.

Knowing never to vex a spirit, especially Cape May's leading Victorian citizen and my host, I soothingly reminded the Physicks that this rebirth of Cape May started with the restoration of their home in the 1970s. "Yes," they all agreed, "we're much happier Victorian spirits now. It was so lonely for a while, but now it's even better than the old days."

I concluded our evening with a toast "to the myriad pleasures of Cape May, and may we enjoy them as long as the Physick family." I then added that Cape May is alleged to be one of the most haunted places in the nation and that this was another attraction to visitors. "Really?" the family answered in unison. Isabelle concluded, "Once you've been here, you never want to leave!" I spiritedly concurred.

Additional Reading

Kopp, Jennifer. *Legacies of Cape May*. Cape May, NJ: Cape May Star and Wave, 2010.

Miller, Ben. *The First Resort*. Cape May, NJ: Exit Zero Publishing, 2009.

Salvini, Emil. *Historic Cape May, New Jersey: The Summer City by the Sea*. Charleston, SC: The History Press, 2012.

Wright, Jack. *Tommy's Folly*. Cape May, NJ: Beach Plum Press, 2003.

Index

INDEX

INDEX

INDEX

About the Author

Robert Heinly holds an EdD and MA in American History from Temple University. He also has an MEd from the University of Pennsylvania. His undergraduate BS in social studies education is from West Chester (Pennsylvania) University. He also has a social studies supervisor's certificate from Pennsylvania.

Robert is allegedly retired after a thirty-three-year career as a social studies teacher and K–12 supervisor in Rose Tree–Media School District in suburban Philadelphia. This district was, and still is, rated as one of the best in the state and nation. He also served as president of the Pennsylvania Council for the Social Studies in 1980 and of the Pennsylvania Social Studies Supervisors Association in 1981 and 1982. During the period 1972 to 1990, he also served on a variety of state and national professional committees and as a consultant for the Pennsylvania Department of Education (PDE). During

that time, he helped create the PDE Goals for Quality Education for the state and the assessment instruments for them. Also during both his more active career and his retirement, he has taught classes in education and American History at Temple, the University of Pennsylvania, LaSalle, Widener and Villanova at night and during the summer. He has also been a textbook consultant and a writer for professional journals.

"Dr. Bob," as he is known in Cape May, now directs the Mid-Atlantic Center for the Arts and Humanities (MAC) Museum Education Program, as well as continuing his lifelong work doing living history, now portraying Dr. Emlen Physick. He also writes a weekly column on Victoriana for the *Cape May Star and Wave* newspaper, as well as doing other occasional consulting work and writing in education and American History.

Visit us at
www.historypress.net
...
This title is also available as an e-book